PAST & PRESENT

SHAWNEE

Opposite: Norton Chevrolet (shown here in 1956) sold vehicles from this location at 116 North Union Avenue as early as the 1920s before moving to Kickapoo Spur in the 1960s. After Norton moved, the building served as warehouse space before being damaged in a tornado and later razed. (Courtesy Pottawatomie County Historical Society.)

Past & Present

SHAWNEE

Brad A. Holt

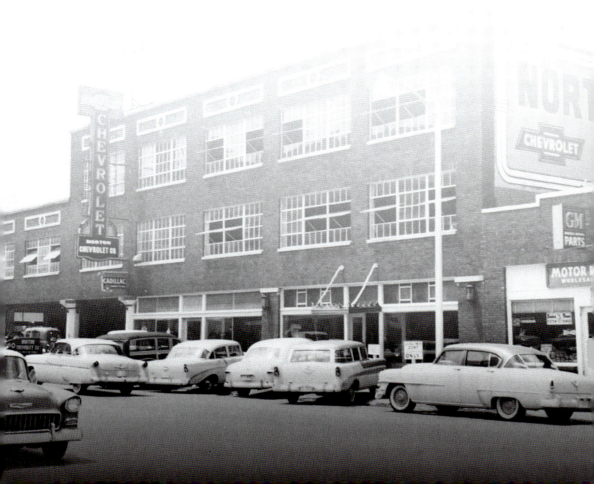

For the two people I have made the trip to Shawnee with the most—my mom, Jennifer, and my brother, Steve. My childhood just wouldn't have been the same without our little weekend road trips up north.

Copyright © 2023 by Brad A. Holt
ISBN 978-1-4671-0959-8

Library of Congress Control Number: 2022949973

Published by Arcadia Publishing
Charleston, South Carolina

Printed in the United States of America

For all general information, please contact Arcadia Publishing:
Telephone 843-853-2070
Fax 843-853-0044
E-mail sales@arcadiapublishing.com
For customer service and orders:
Toll-Free 1-888-313-2665

Visit us on the Internet at www.arcadiapublishing.com

On the Front Cover: This is a view of brick-lined Bell Street looking north from Main Street. Clockwise from bottom left are the Federal National Bank, Petroleum Building, Bell Telephone Building, Campbell and Edwards Photographers Building, Shawnee Garment Factory, and Dexter Building. (Past image courtesy Pottawatomie County Historical Society; present photograph by author.)

On the Back Cover: Richard's Drug opened at 324 East Main Street in 1939. This photograph shows the drugstore as it looked in 1955, when it was affiliated with the Rexall chain. The pharmacy served the community for over 80 years before announcing it would close on December 31, 2020. (Courtesy Pottawatomie County Historical Society.)

Contents

Acknowledgments		vii
Introduction		ix
1.	Main Street	11
2.	Bell Street Historic District	37
3.	Broadway Avenue	55
4.	Elsewhere Downtown and Beyond	67
5.	Schools and Churches	83

Acknowledgments

As with my previous book, I must once again gratefully acknowledge and convey my sincere thanks to the Pottawatomie County Historical Society, Ken Landry, and the rest of the staff who work so hard to document and preserve the history of Pottawatomie County. Without access to their immense collection of photographs and knowledge, this book would have never happened.

My appreciation goes out to Karen Duvall Lanier and Renah Coffman Barton for reviewing the content and proofreading. Your feedback was invaluable. Gratitude goes out as well to the many members who contribute to the Pottawatomie County Historical Society's Facebook page. It was an extremely useful resource during this process.

A big thank you to Karen Dorrell for once again proofreading the book. I appreciate you immensely, and I hope you enjoyed seeing photographs and reading more about your college-years town.

I would like to recognize those business owners, city leaders, investors, and visionaries who see potential in turning around an old building and bringing it back to life. Without these individuals, Shawnee's downtown revitalization would not be possible.

Finally, I would like to express my gratitude to my editor at Arcadia, Caitrin Cunningham, for her guidance and assistance with the book.

Unless otherwise noted, all past photographs are courtesy of the Pottawatomie County Historical Society. All present photographs were taken by the author. Credit goes to the City of Shawnee for providing some of the historical background featured in the introduction.

Introduction

Shawnee will always be a memorable place for me. As I am originally from Asher, doing much of anything (fun or practical) very often involved a trip up to Shawnee. While downtown was not always a big part of the trips, I was fascinated by the brick-lined streets of Bell Avenue, and it was always a treat to catch a 50¢ movie at the Hornbeck. And a trip downtown was never complete without a trip to Walls to see what bargains we could find in the basement. Once the mall was built, I would make frequent trips (often with my mom and brother in tow) to do some shopping or watch a movie. And my junior prom was held where else but the Cinderella Inn. Later in life, as I became more interested in historic buildings and areas, I was able to appreciate downtown even more. It is impressive that these structures have managed to survive almost a century (or longer) in this day of urban renewal and throwing out the old for new. This is, perhaps, even more impressive in smaller communities like Shawnee, which cannot always afford to keep up or rehabilitate older buildings. I have enjoyed watching the transformation of the downtown area over the last several years and seeing facades removed from several buildings to reveal a bit of the structures' glorious past. There is still a lot of work to do, of course, and I hope this trend of bringing back some of the old downtown continues.

Shawnee has a strong sense of place, owing to a rich history dating back to 1895. Before Shawnee was established, the area was inhabited by several tribes the federal government had removed to Indian Territory, including, originally, the Sac and Fox, followed by the Kickapoo, Absentee Shawnee, and Potawatomi Indians. Those tribal members continue to live in the Shawnee area today.

Building up to the start of Shawnee's history was the land run. In April 1889, the federal government succumbed to pressure and began opening Indian lands to white settlement. At noon on September 22, 1891, Shawnee pioneers Etta B. Ray, John and Lola Beard, J.T. Farrall, Elijah Ally, and many others set off for the site of present-day Shawnee. By the end of 1891, John Beard determined that railroads would be the key to Shawnee's success. With the aid of other settlers, he reached out to various railroads, urging them to come to Shawnee. The task was considerable since Tecumseh had already been named the county seat. Nevertheless, by the fall of 1894, the Choctaw Railroad committed to coming through Shawnee. Tracks were completed from Oklahoma City to Shawnee by July 4, 1895, and the town was officially established. In February 1896, terminal facilities for the Choctaw Railroad were built in Shawnee, but it was the decision of the Choctaw to relocate its main repair shops from McAlester that served to promote significant growth. The shops provided a strong employment base for the city.

For the first few years of the new century, Shawnee was amid a boom that came close to keeping pace with Oklahoma City, but by 1910, it was increasingly clear that Shawnee could no longer vie with Oklahoma City for dominance in the region. The city came in a distant third in the statewide election to determine the permanent site of the state capital. The city, however, was successful in securing both a Baptist university (Oklahoma Baptist University) and a Catholic

college (St. Gregory's). As some consolation for losing out on the state capital, a county election in 1930 resulted in the county seat moving from Tecumseh to Shawnee.

Along with the rest of Pottawatomie County, Shawnee experienced a growth spurt in the 1920s with the onset of the Oklahoma oil boom. The boom stimulated residential construction, oil-related businesses, and the entertainment industry. Unfortunately, this boom subsided with the stock market crash and the Great Depression of the late 1920s and 1930s. Shawnee's survival was aided by the programs of the New Deal, which helped construct the new county courthouse, the municipal auditorium, several elementary schools, and other facilities. World War II helped dig Shawnee and the rest of the country out of the Depression. The construction of Tinker Air Field, west of Shawnee in Midwest City, also benefited Shawnee's economy.

In the 1940s and into the 1950s, Shawnee was experiencing a "golden age," being the most prosperous it had been in many years and with a population on the rise. With the opening of Interstate 40 and US Highway 177 in the 1960s, the city began to expand outward, which also signaled the first signs of trouble for shops downtown. This migration away from downtown would continue for many years.

Throughout the 1970s and 1980s, in an attempt to keep up with the styles and preferences of the day, many downtown owners added false facades to their properties. In hindsight, these facades did not hold up well (visually or physically), and much of the charm of the downtown area was lost. However, over the past several years, downtown Shawnee has undergone revitalization efforts, which included new streets, sidewalk improvements, new traffic signals, added wayfinding signage, and restorations to some storefronts. While downtown Shawnee has lost many buildings of historical value, it still retains plenty of the past to allow current residents to imagine how life once was.

I have grouped the chapters that follow by area, focusing primarily on downtown, including Main Street, Bell Street Historic District, and Broadway Avenue. The photographs are ordered as you would see them driving down the street. Of course, not all of Shawnee's historic structures are limited to those areas, so I have included a chapter with a smattering of photographs from elsewhere downtown and beyond. Finally, I grouped some of Shawnee's historic schools and churches into their own chapter at the end. Due to space limitations and the availability of historic photographs, I am sure a few of your favorite buildings may be excluded, but I have done my best to deliver a good representation of past Shawnee. I hope this stroll down the historic streets of Shawnee brings back many fond memories!

CHAPTER

Main Street

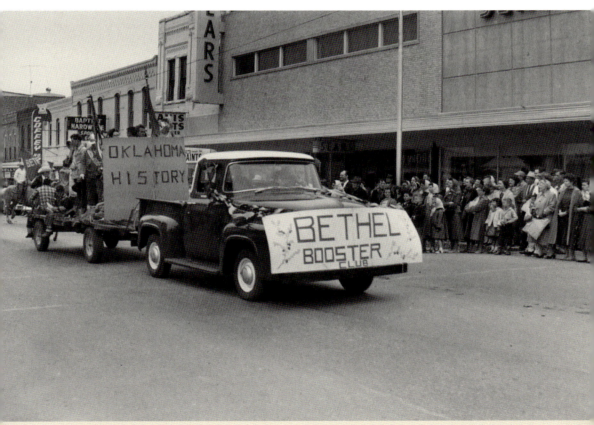

A crowd of people lines the street to watch a float in the Redbud Parade as it rolls up Main Street approaching the corner of Union Avenue in the spring of 1957. Parades such as this have been a common occurrence in Shawnee's history, with the majority occurring on Main Street.

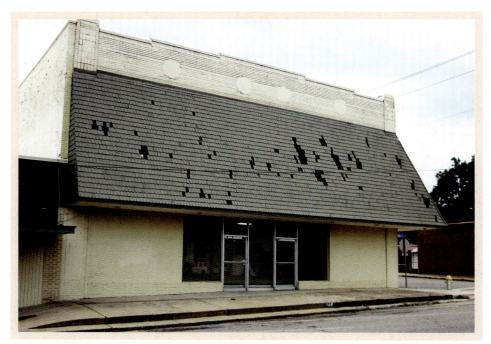

This two-story building at 507 East Main Street, just west of the depot, was once the home to the Last Chance Saloon and Hotel. It was so named as it was the last chance to get a drink before catching a train. In the 1961 picture below, Newton Wall Co. (better known as Wall's Bargain Store) was the tenant. Today, shoppers still dig for bargains here, but Wall's has moved to a different location.

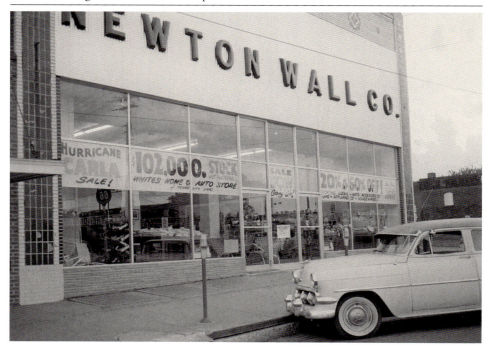

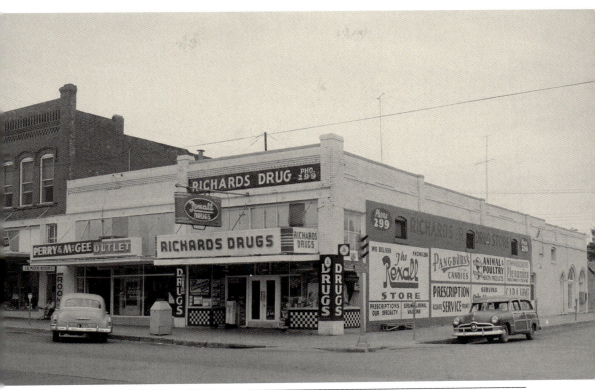

Richard's Drug opened at 324 East Main Street in 1939. The photograph above shows the drugstore as it looked in 1955, when it was affiliated with the Rexall chain. The pharmacy served the community for over 80 years before announcing it would close on December 31, 2020. The building has since been empty. Viewable in the present photograph is Hamburger King, which has been in business on Main Street since 1927. It moved to this location in 1964 and still serves burgers today.

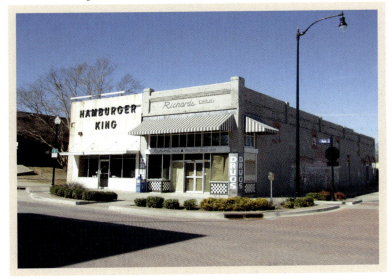

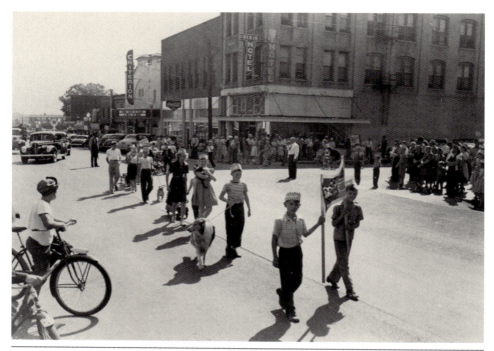

The southeast corner of Main Street and Philadelphia Avenue is captured here, with the Dixie Hotel and Criterion Theater featured. Although undated, the photograph above was probably taken between the 1930s and 1950s. While the buildings on the immediate corner survived into the 1980s, they were the victim of a fire and were later razed. Celebration of Life Park was built on the site. Some of the structures farther down, including the two-story building at Oklahoma Avenue, still exist.

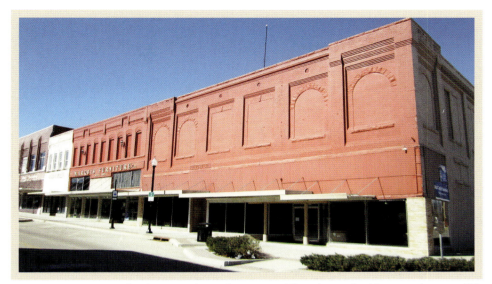

Marquis Furniture and Kib Warren's, at the corner of Main Street and Philadelphia Avenue, are shown in the 1966 photograph below. Marquis Furniture had its start in 1905, although its building is a few years older, constructed in 1903. The adjacent building was home to Kib Warren's for many years before later being taken over by the furniture store in an expansion. Sadly, in 2022, Marquis Furniture announced it was closing after 117 years in business.

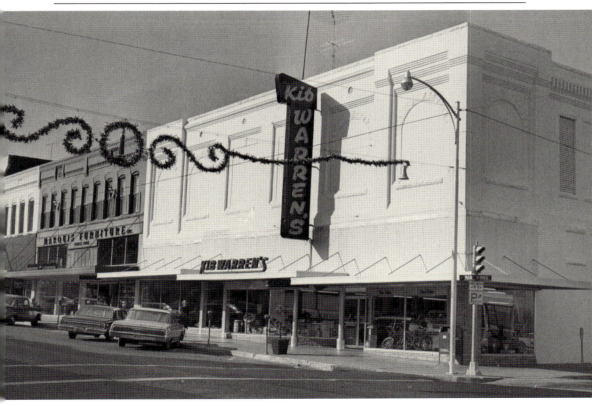

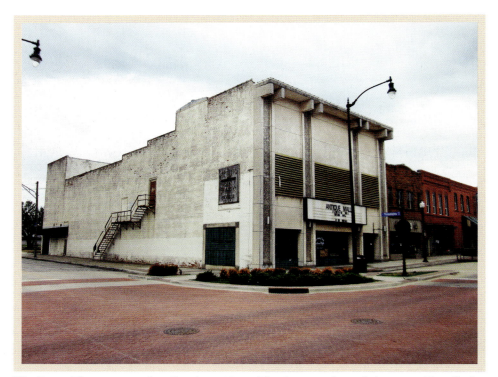

The Bison Theater opened in October 1927 at Main Street and Philadelphia Avenue with seating for over 1,000 patrons. The Art Deco interior featured a domed ceiling and included a complete working stage with a fly loft for scenery. The theater is shown below in 1966, well after it closed in the 1950s. The building remains today, but the facade has been heavily modified. The marquee was moved to the Ritz Theater in 1966. (Past image courtesy of Jones Theatres.)

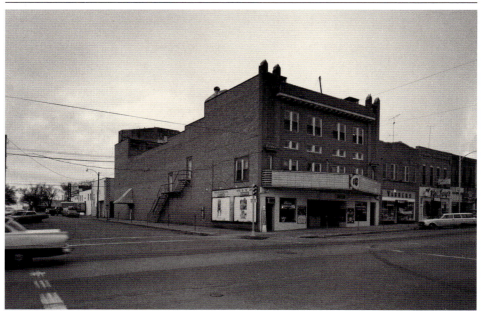

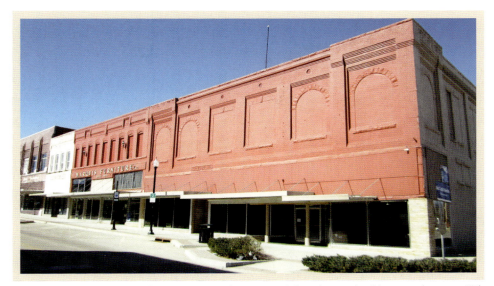

Marquis Furniture and Kib Warren's, at the corner of Main Street and Philadelphia Avenue, are shown in the 1966 photograph below. Marquis Furniture had its start in 1905, although its building is a few years older, constructed in 1903. The adjacent building was home to Kib Warren's for many years before later being taken over by the furniture store in an expansion. Sadly, in 2022, Marquis Furniture announced it was closing after 117 years in business.

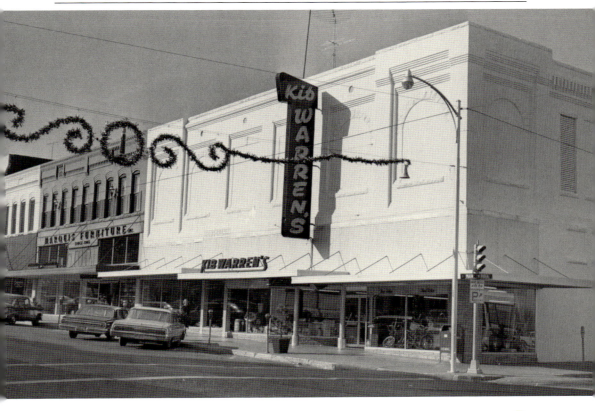

MAIN STREET

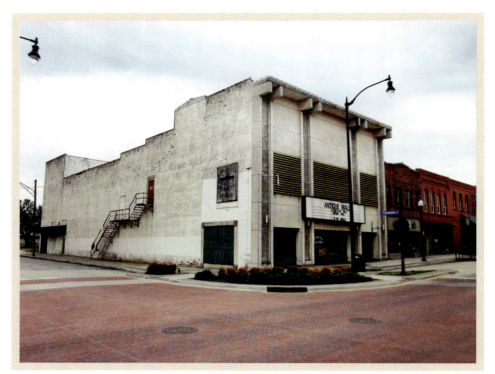

The Bison Theater opened in October 1927 at Main Street and Philadelphia Avenue with seating for over 1,000 patrons. The Art Deco interior featured a domed ceiling and included a complete working stage with a fly loft for scenery. The theater is shown below in 1966, well after it closed in the 1950s. The building remains today, but the facade has been heavily modified. The marquee was moved to the Ritz Theater in 1966. (Past image courtesy of Jones Theatres.)

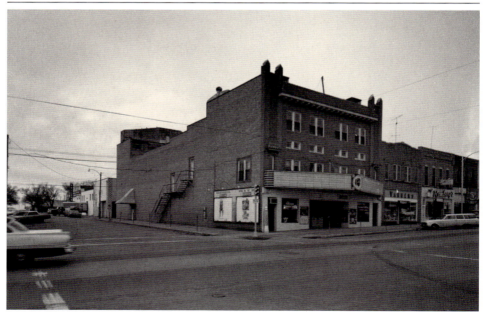

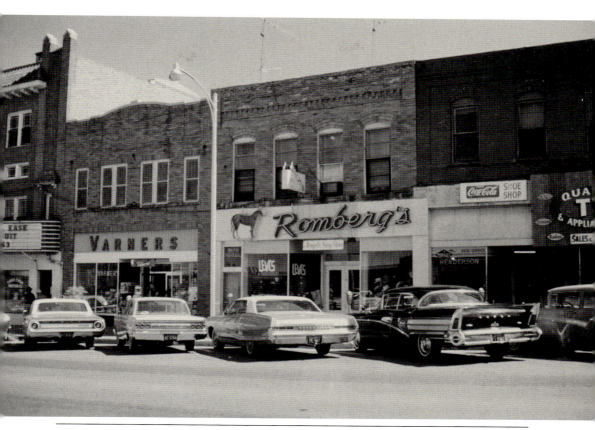

This 1957 photograph shows the south side of Main Street between Philadelphia and Union Avenues. Bison Theater (closed by this time), Varners Five and Dime, and Romberg's western wear can be seen here. Romberg's would later move two buildings east into the old Bison Theater Building after it was questionably "modernized" with a false facade. Many Shawnee citizens may recall going into Radio Shack, which later took over the Varners building but has since closed.

MAIN STREET

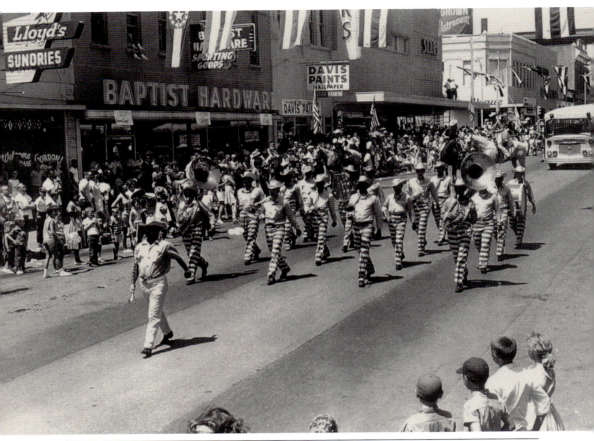

Judging by the "Welcome Home Gordon" message visible in a store window at left, this is most likely the Gordon Cooper Parade Shawnee held in 1963. Lloyd's Sundries, Baptist Hardware, Davis Paints, and Sears at the corner of Union Avenue and Main Street are visible. These stores are all gone today, with Baptist Hardware being the last to go in 2013. However, all the buildings remain, some with new owners while others are vacant.

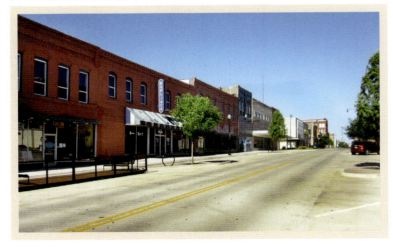

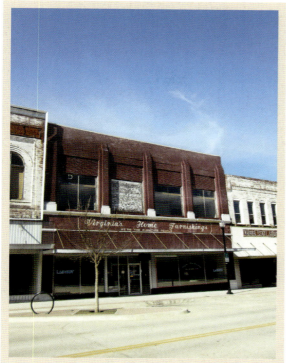

The Longmire-Draper Company was an early occupant of this building at 212 East Main Street. William Longmire opened the store in 1903, selling furniture and carpet. In 1916, Longmire added a department store. By 1923, the store appeared to be in trouble and advertised an "Everything Goes" sale. Most recently, the building has been home to Virginia's Home Furnishings. At some point in history, the third floor of the building, with its decorative molding and large arched windows, was removed.

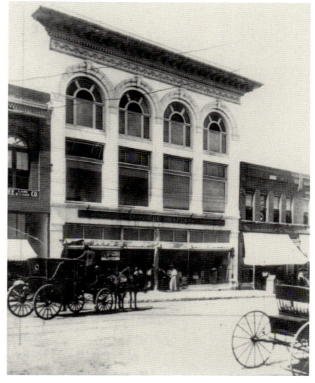

In the photograph below, a group of Shriners walks down Main Street past Union Avenue during a 1957 parade. The large building near the center of the photograph is the Bank of Commerce. This landmark structure and two adjacent buildings were razed in 1960 to build a new J.C. Penney store. Union Street Station, a mini-mall, was built on the northeast corner on the Walcott Hotel site, but it has since closed. Most of the remaining buildings in this view looking west remain.

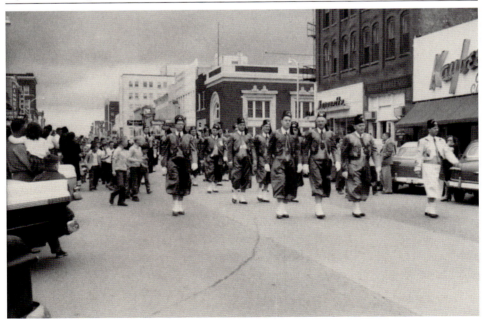

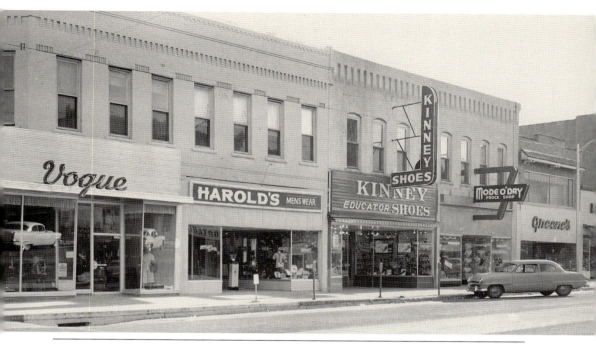

The building on the southwest corner of Main Street and Union Avenue was built in the early 1900s and originally served as a bank. In the 1956 photograph above, Vogue and Harold's Men's Wear occupy the spot, with Kinney Shoes, Mode O'Day Frock Shop, and Greene's visible farther down. All three of these buildings exist today; however, the two larger structures are mostly unrecognizable.

Main Street

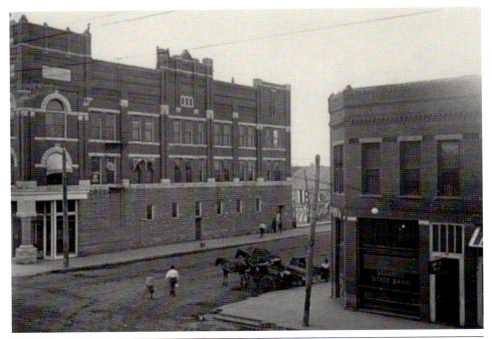

As evident from the dirt streets and parked horses, this is a very early photograph of the south side of Main Street and Union Avenue. The Whittaker Building and Security State Bank are prominently featured. The Whittaker Building was torn down in 1947 to make room for a new Sears store. That building remains on the site today, but it is currently vacant. Across the street, the structure that once housed the Security State Bank remains but has been heavily modified.

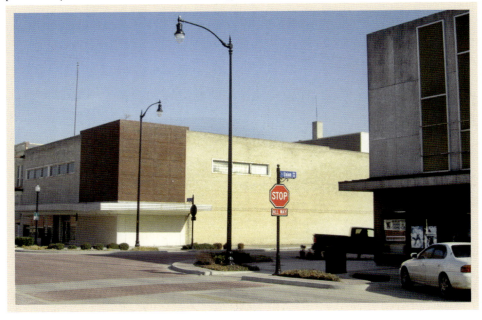

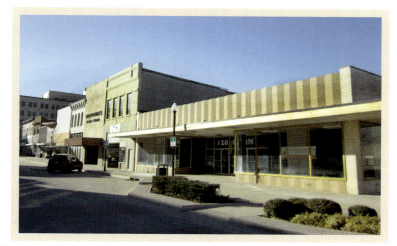

In the photograph below, shoppers line up to enter the new J.C. Penney store at 120 East Main Street during its July 1960 grand opening. Three historic structures, including the Bank of Commerce Building, were demolished to make way for this mid-century shop. Although Penney's has long vacated this building, it remains and currently awaits a new tenant. The remaining buildings visible in the photograph also still exist but have been subjected to various levels of modernization.

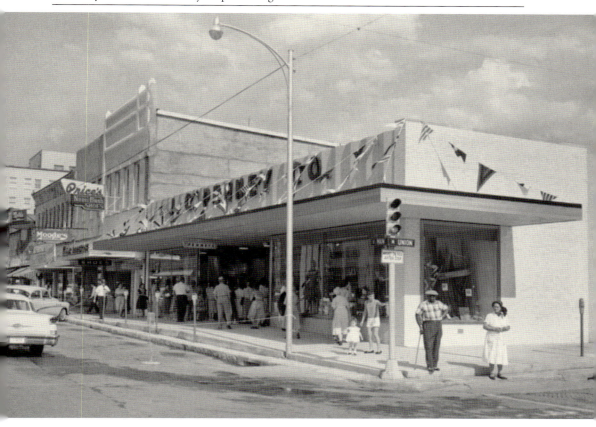

MAIN STREET

Price's was one of Shawnee's favorite downtown places to shop for new shoes. The shop at 118 East Main Street is shown below as it appeared in 1958, only a few years before its neighbors to the east would be razed for a new J.C. Penney store. Although the upper portion of this building was largely covered by modifications in the 1960s, the structure is mostly back to its original appearance today and serves as a gift shop.

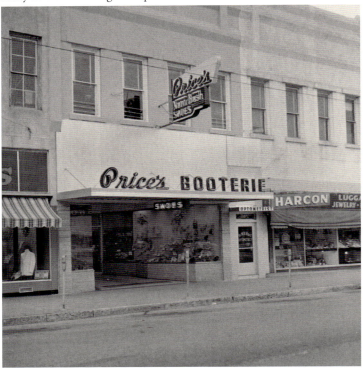

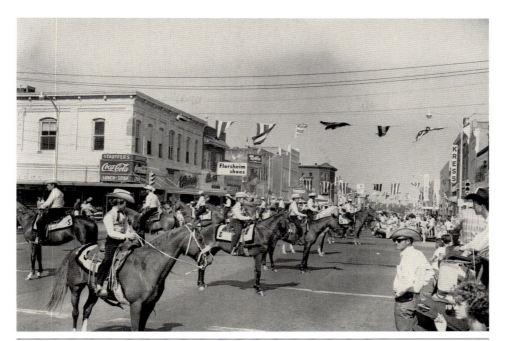

Horses and riders entertain the crowd during a Roundup Parade. The July 1964 photograph above was taken at the intersection of Main Street and Bell Avenue with the Dexter Building at left. This block was a shopper's paradise, with Blaine's Dress Shop, Pratt Shoes, Sperry's Jewelry, Price's Shoes, Sears, and Kress just a few of the shops visible. This group of buildings largely remains today except for the Burt/Walcott Hotel, visible in the far back with the peaked center front.

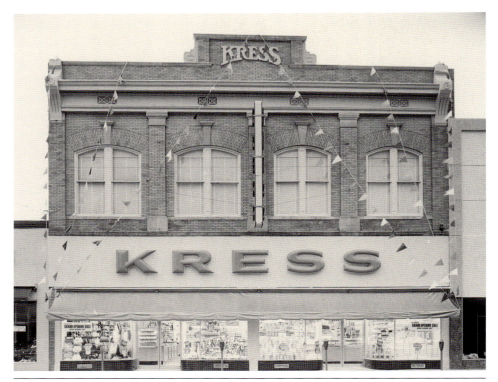

The Kress Building is located at 109 East Main Street. S.H. Kress & Co. was a chain of five and dime retail department stores that could be found in towns across the country. Shawnee's store opened in 1907 and closed in 1980. Originally only about half this size, the store overtook a neighboring lot and doubled the building to the size it is today. The structure still stands mostly unaltered and is home to an office supply store.

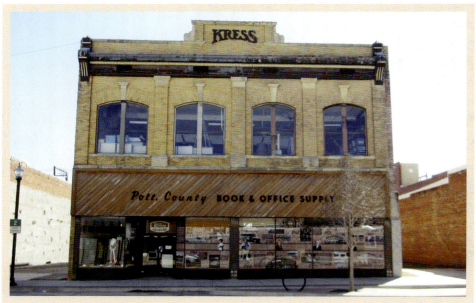

Central Drug Co. previously called the old State National Bank building on the northwest corner of Main Street and Broadway Avenue home before moving to this location on the southeast corner of the same intersection. In the August 1965 photograph below, Tipton's Jewelry Store can be seen at left and Gibson's Discount Center across the road to the right. Sadly, the original facades of all these buildings have been covered.

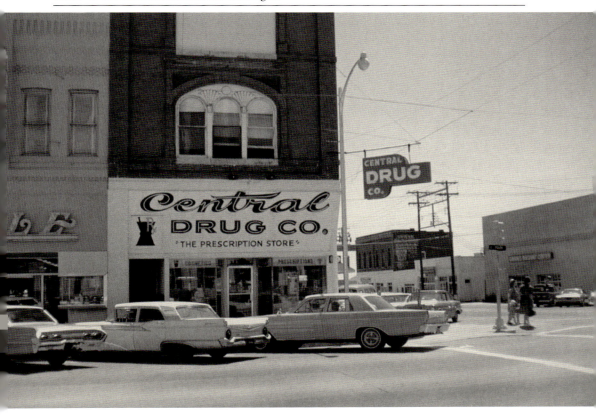

MAIN STREET

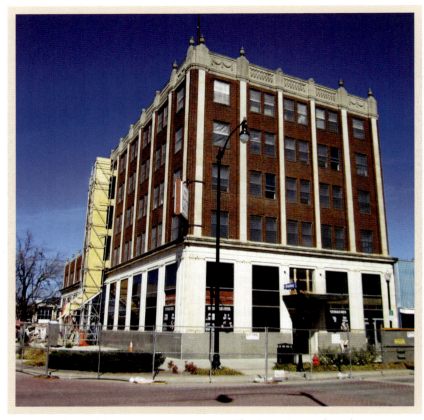

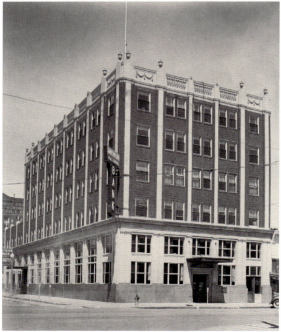

The State National Bank was organized in 1902 and was originally located on the northwest corner of Main Street and Broadway Avenue. The bank constructed a much larger building on the northeast corner in 1929 but suffered during the Great Depression and closed in 1933. It reopened under a new charter in 1934 as American National Bank of Shawnee and was serving as such when the photograph at left was taken in April 1941. The building is currently being restored.

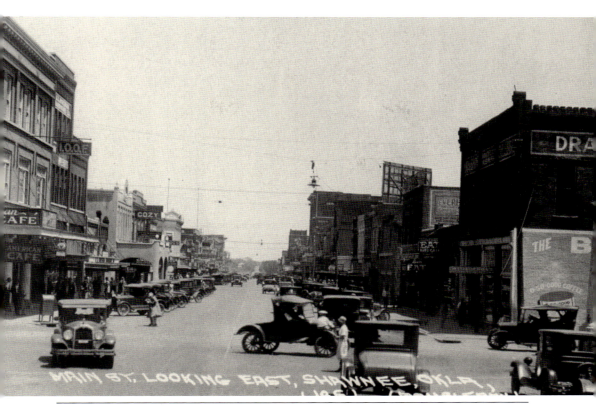

Looking east from Beard Avenue, Main Street is captured in the photograph above from the early 20th century. Visible on the north are the Chrisney Building, Roebuck Building, and Cozy (later Ritz) Theater. On the south is a two-story structure that has served many businesses over the years, including Draughon's Business College and M&P Stores. Farther down, there is a group of smaller structures, one being a small furniture store that is now home to Boomerang Diner. Sticking up toward the back of the photograph is the Mammoth Department Store (now home to Neal's Furniture).

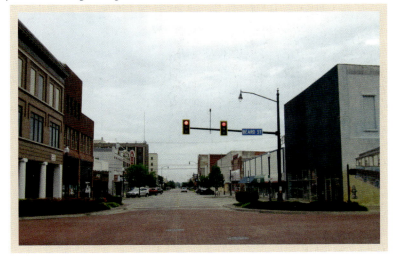

Main Street

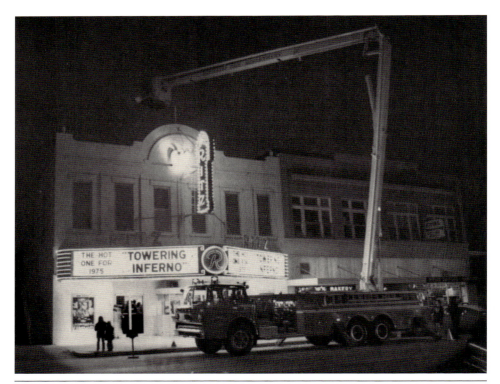

The Shawnee Fire Department added a little drama at the Ritz Theater when it was showing *Towering Inferno* in 1975. The theater, which was built around 1899 and showed some of Shawnee's first talking motion pictures, was originally named the Cozy but changed names in 1926. An original arched front was removed in a 1960s remodel and replaced with the marquee from the Bison Theater. The movie theater closed in 1988, but it now operates as a live theater.

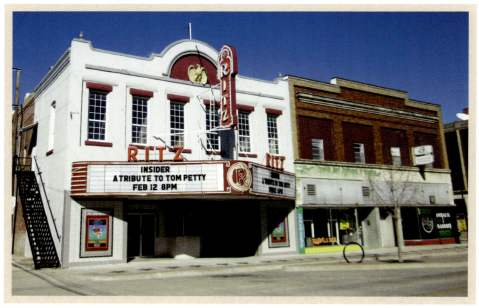

Below, this 1960s photograph taken at Broadway Avenue looking west on Main Street shows Modern Home & Auto, Oklahoma Tire & Supply (OTASO), Modern Grill, and, across the street, the Ritz Theater. In 2023, after the present image was taken, the abandoned Modern Home & Auto Building was razed; however, most of the other buildings in this block still stand. The OTASO Building now houses Boomerang Grill. The Ritz Theater, now without the arched front, still welcomes theatergoers today.

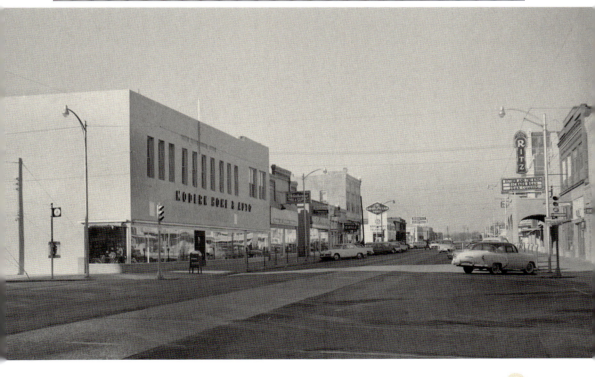

MAIN STREET

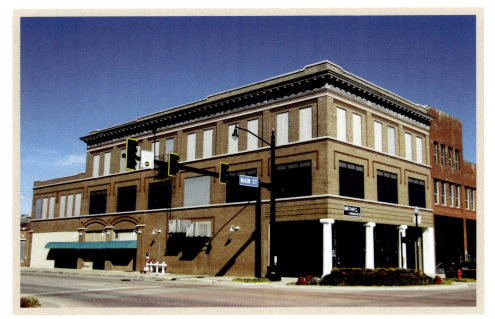

The Chrisney Building, completed and opened in January 1908, has long stood at Main Street and Beard Avenue. One of the first tenants was the Public Drug Co., with smaller professional offices and sleeping rooms located on the upper floors. Its neighbor to the right is the J.L. Roebuck Building. The Chrisney Building is now home to an insurance agency, with the Roebuck Building still standing next door.

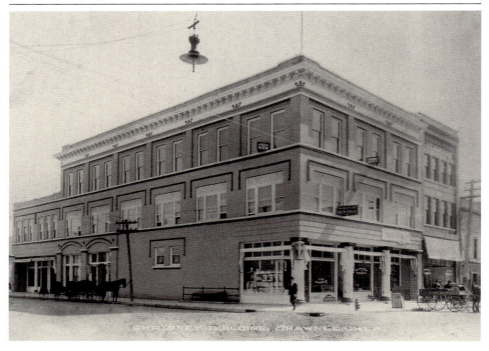

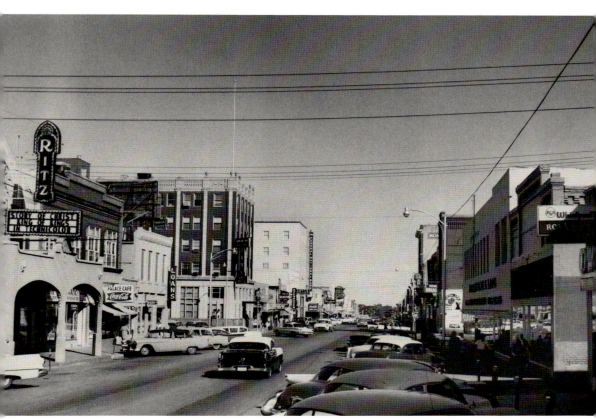

Automobiles line Main Street from this vantage point looking east from Beard Avenue. Taken in 1961, this view is still strikingly similar today. The Ritz Theater, State/American National Bank Building, and Federal National Bank Building on the left still stand. Most of the structures on the opposite side, including the Mammoth/Montgomery Ward Building and Central Drug Building, remain; however, the Modern Home and Auto Building was razed after the present image was taken.

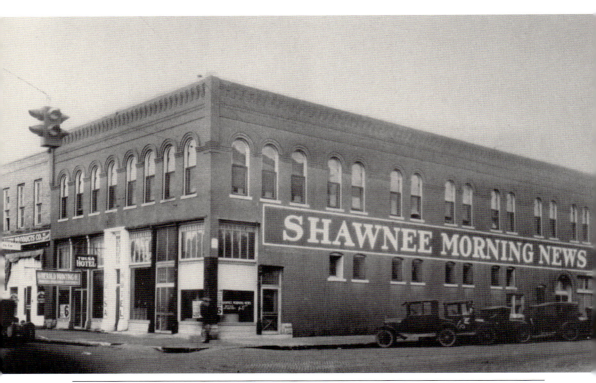

The *Shawnee Morning News*, the successor to the *News-Herald*, was published from 1919 to 1943 and had its home on the northwest corner of Main Street and Beard Avenue. The paper merged with the *Shawnee Evening Star* in 1943 to become the current *Shawnee News-Star*. This building later was decorated in a mission style and served as an Army surplus store. The structure still stands today, although it is visibly different from the original.

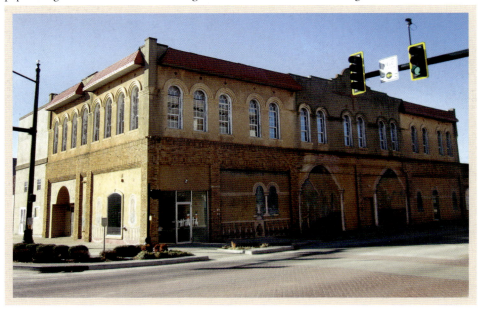

Mac's Gas House served the public from the unique building pictured below on the southwest corner of Main Street and Beard Avenue. The station had overhead doors inside leading into service bays located in the adjacent building. The Majestic Hotel was located upstairs. Although this photograph is undated, based on the gas price, it may have been taken in the 1930s or 1940s. While this structure is gone today, the adjacent building with the overhead doors remains.

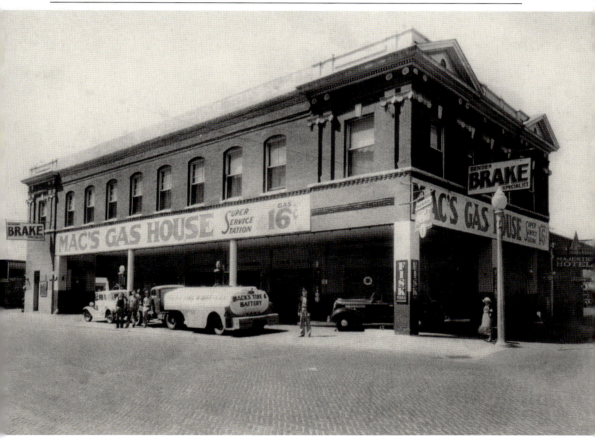

MAIN STREET

Union Bus Station, on the corner of Main Street and Market Avenue, was just one of many properties affected by the October 5, 1970, tornado that struck Shawnee. The deadly tornado killed four people, injured several more, and damaged 157 businesses, 564 homes, 12 public buildings, 10 churches, and 5 schools. The bus station reopened after repairs. The building still stands today but appears to be used for storage.

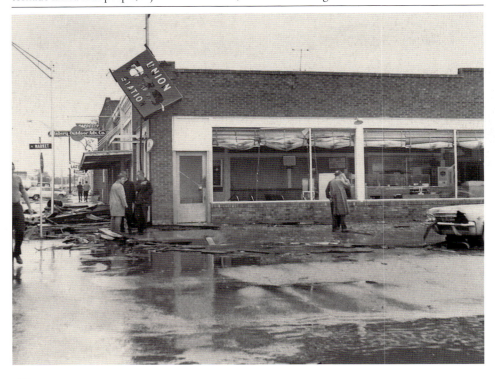

CHAPTER 2

BELL STREET HISTORIC DISTRICT

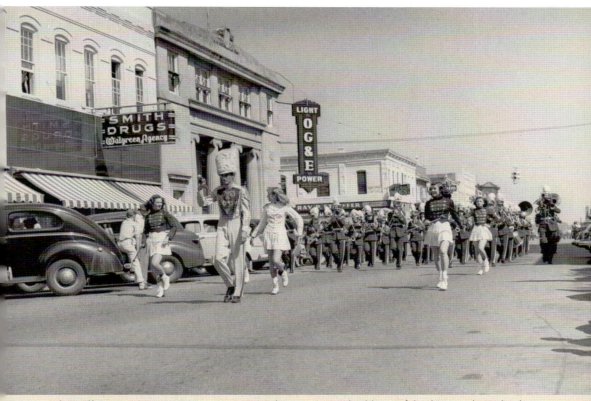

The Bell Street Historic District, recognized by the National Register of Historic Places, represents the heart of commercial development in Shawnee and contains several architecturally interesting styles, with construction spanning the first half of the 1900s. This 1947 photograph, taken at Main Street and Bell Avenue, shows two prominent buildings of the district, the Federal National Bank (home to Oklahoma Gas & Electric when this photograph was taken) and the Dexter Building across the street. While the thoroughfare was originally named Bell Street, it was rechristened Bell Avenue in modern times.

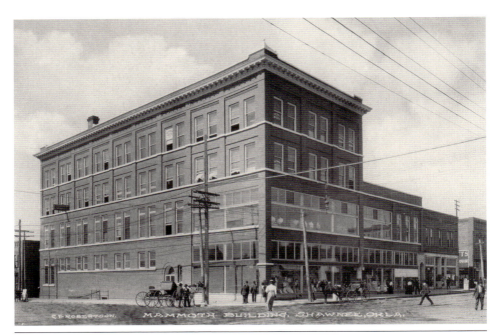

With four stories, the Mammoth Department Store was one of the largest department stores in the area. The building was constructed in 1907 on the southwest corner of Main Street and Bell Avenue. The store, which moved from a smaller location, carried clothing, housewares, furniture, and more. In the 1940s, it became a Montgomery Ward. The building, now a home furnishings store, retains many of its period features, including bracketed cornices on the upper section of the structure.

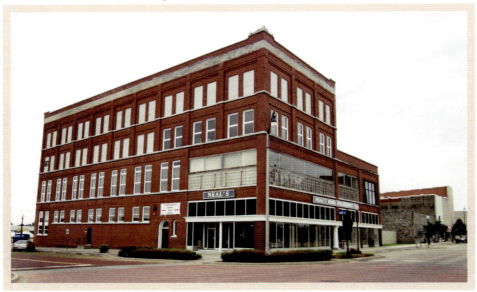

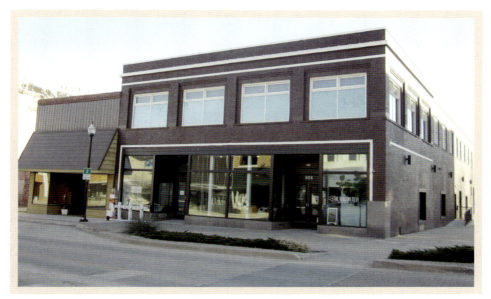

This building, occupied by Woolworth's Department store from 1940 to 1970, is located at the corner of Main Street and Bell Avenue. The structure, which was completed in 1900, has since been painted; however, decorative elements of the past are still present, making it a contributing resource to the Bell Street Historic District. The adjacent building, which was once home to Arden's, also still exists but is heavily modified.

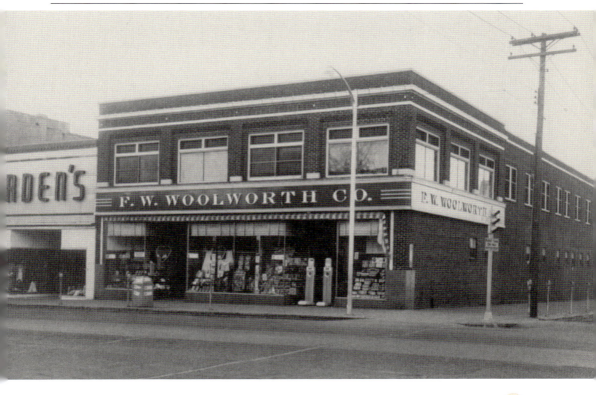

BELL STREET HISTORIC DISTRICT

This structure sits on the northwest corner of Main Street and Bell Avenue and was constructed in 1907. It was originally home to Shawnee State Bank until its closure in 1932. Afterward, Oklahoma Gas & Electric had an office here for about a decade. The photograph below was taken in 1949, two years after four additional floors were added, the front was remodeled, and Federal National Bank was a new tenant. In 2000, the bank (now a branch of BancFirst) closed. The building is for lease.

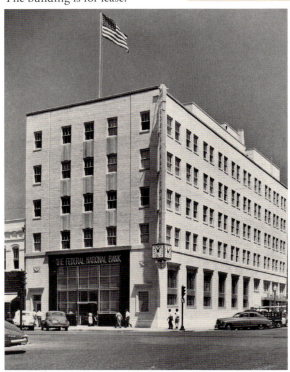

BELL STREET HISTORIC DISTRICT

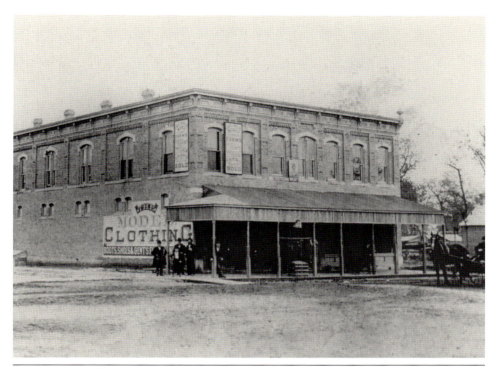

The Dexter Building, constructed in 1895, is located at the corner of Main Street and Bell Avenue. This two-story building is the second oldest structure in the downtown core. Restoration efforts, including the removal of a false facade covering the second floor, began in 2012. New storefronts were previously cut into the side of the building and a large part of it painted, but the structure is still largely recognizable and a contributing property to the Bell Street Historic District.

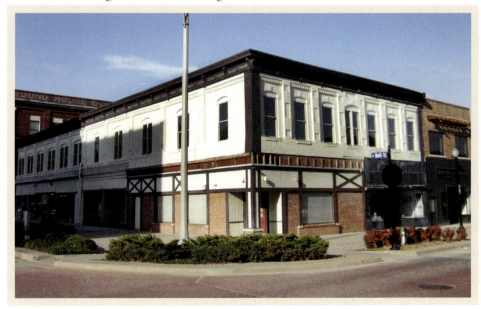

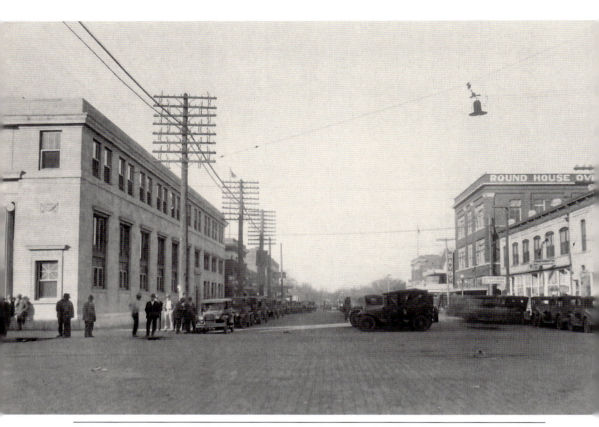

This view of brick-lined Bell Avenue is looking north from Main Street. Many of these structures survive today and contribute to the Bell Street Historic District. Clockwise from bottom left are the Federal National Bank (completed 1907), the Petroleum Building (1914), the Bell Telephone Building (1916 or 1927), Campbell and Edwards Photographers Building (c. 1900), Shawnee Garment Factory (1910), and the Dexter Building (1895).

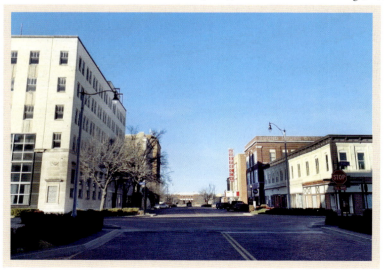

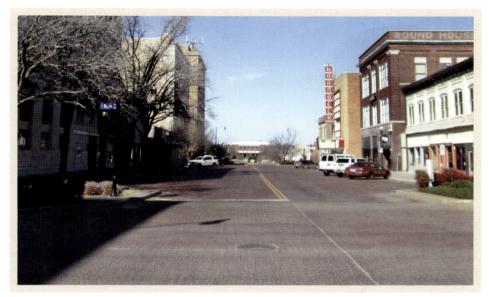

Below is a later view of Bell Avenue looking north from Main Street toward Shawnee Municipal Auditorium during a Red Bud Parade. This photograph differs from the previous in that the Federal National Bank has gained additional floors and the Billington/Masonic Building (1929) and Aldridge Hotel (1929) have been constructed. Across the street, the Hornbeck Theater (1947) has also gone up. All of the buildings endure today.

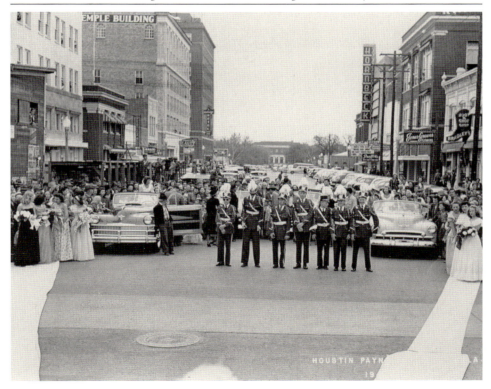

BELL STREET HISTORIC DISTRICT

The Petroleum Building (left, at 116 North Bell Avenue) was constructed in 1914 and originally housed offices for petroleum companies. The structure at 120 North Bell Avenue, on the right, was constructed in 1900 and housed Steward Meat Market and later the Home Federal Savings & Loan Association, along with other establishments. Both buildings received facades in the 1970s causing them to lose their historical architectural integrity and are thus considered noncontributing resources to the historic district.

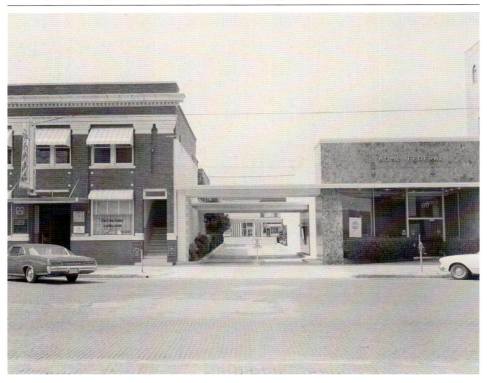

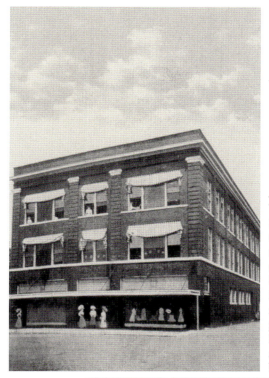

This three-story redbrick building at 113 North Bell Avenue, originally home to the Shawnee Garment Factory, was completed in 1910 in the Classical Revival style. Still faintly visible on the north side is a sign reading "Round House Overalls Fit Better." Round House overalls were manufactured here after moving from its previous facility on Main Street. Round House jeans and overalls continue to be manufactured in Shawnee. Today, the building is home to a restaurant and bar.

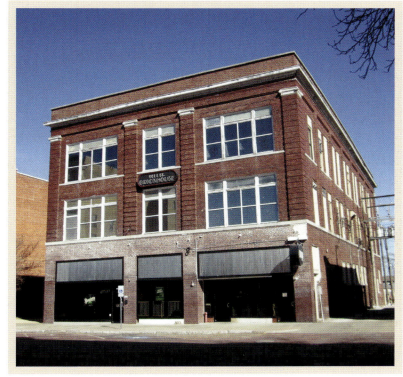

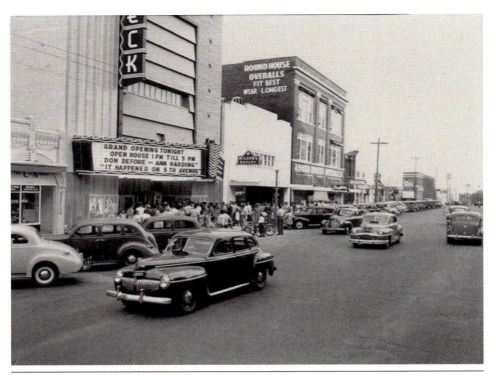

The Hornbeck Theater at 125 North Bell Avenue (shown here on opening night) was built in 1947. Its Modern Movement design, featuring modern lines and lots of neon, is the only one of this style in downtown Shawnee. The Hornbeck opened as a single-screen theater but was remodeled into a piggyback twin in 1973 (with the upper theater being known as the Penthouse). Sadly, the theater closed in 2020 amid the COVID-19 pandemic.

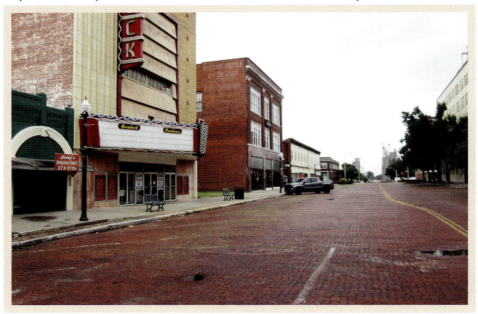

A portion of the Billington Building is shown below as it looked in 1961. Oklahoma Gas & Electric occupied one of the spaces, and a Bell Systems Telephone business office filled the other. Both of these units seek new inhabitants today. Just visible to the left is a portion of 124 North Bell Avenue. This small commercial property was built in 1905. The building's facade was added around 1970.

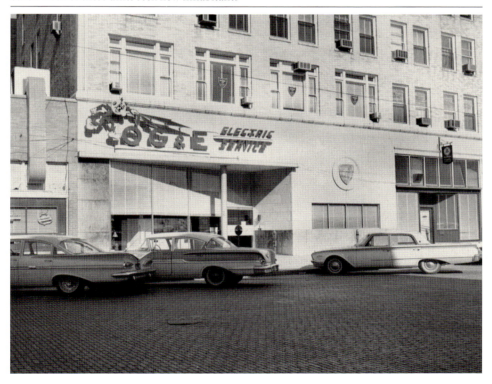

BELL STREET HISTORIC DISTRICT

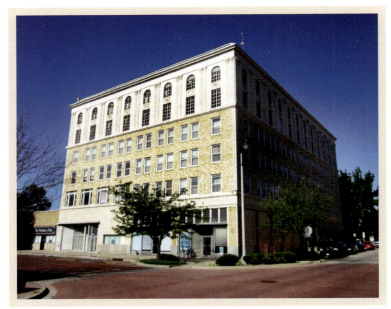

The Billington Building is a seven-story structure on the southwest corner of East Ninth Street and North Bell Avenue. Constructed in 1929 by C.B. Billington at a cost of $300,000, it is recognized as one of the first "skyscrapers" in Shawnee. Billington was a Mason, and the Shawnee Masonic Lodge used the top two floors as a meeting hall. Those floors are adorned with Masonic symbols over the windows. Today, the structure serves as an office building.

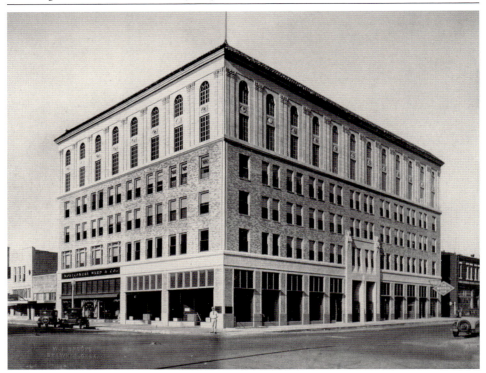

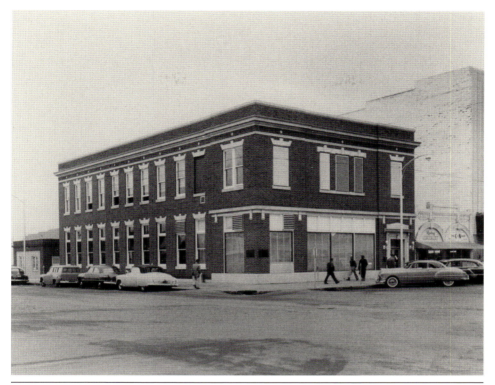

The Bell Telephone Building (photographed in 1953) is located at the corner of East Ninth Street and North Bell Avenue. This two-story Colonial Revival structure was constructed in two stages (1916 and 1927) and is a contributing property to the Bell Street Historic District. After serving as home to the Shawnee Chamber of Commerce for a time, it now houses a transit authority. Although modified in the 1980s, the building exterior remains mostly historically intact. (Past image courtesy of the National Archives.)

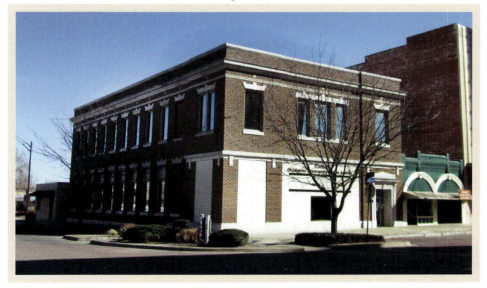

BELL STREET HISTORIC DISTRICT

Boasting 10 stories, the Aldridge Hotel is the tallest downtown building. The establishment, originally known as the Hilton Phillips Hotel, opened in 1929. Located at the corner of East Ninth Street and North Bell Avenue, it was Shawnee's leading hotel through the 1940s. The hotel closed in 1994; however, in 2005, the building was restored for use as one- and two-bedroom apartments for senior adults. Today, the building retains much of its Neoclassical charm.

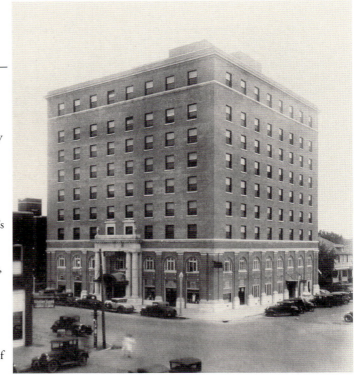

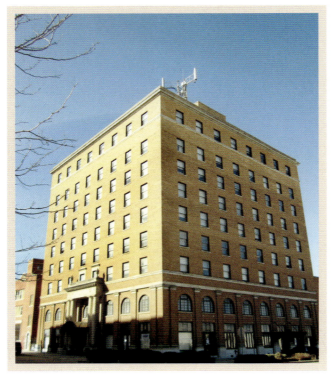

Below is a 1967 view of Bell Avenue looking south from East Ninth Street. The scene looks very familiar today, even over 50 years later. Most of these buildings still proudly stand tall, although the smaller structures between Federal National Bank and the Billington Building have received "updated" facades. The structure housing the City Café next to the Hornbeck is now an empty lot.

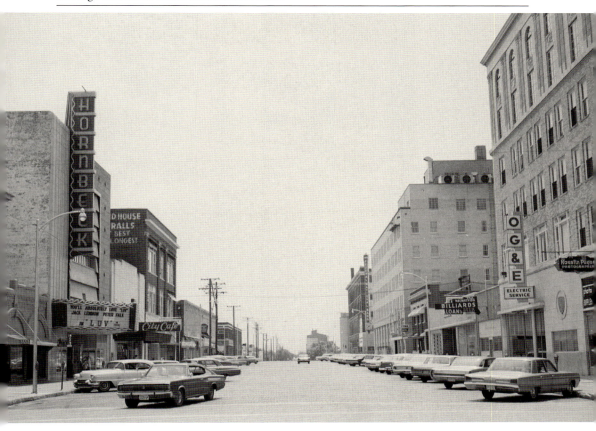

BELL STREET HISTORIC DISTRICT

A bowling alley and the *Shawnee News-Star* office are pictured below in 1964. Only a few years later, both these buildings would be demolished for a larger newspaper office. The *News-Star* would occupy the new building at 215 North Bell Avenue for many more years. The building has been vacant since the newspaper started printing the paper out of town and moved its office to a smaller space.

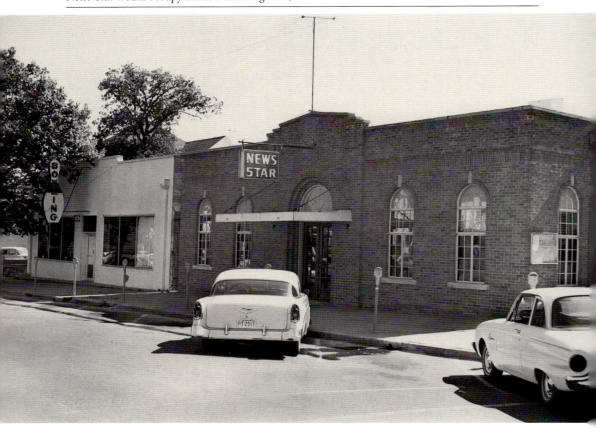

This photograph shows the north end of Bell Avenue looking toward the Municipal Auditorium. Although undated, the cars would indicate it was probably taken in the 1950s. A sign for Finley's Dry Cleaners can be seen at left. The rows of houses are no more, having been replaced with surface parking. The mailbox median too is gone, controversially moved away from this convenient location after the street was resurfaced.

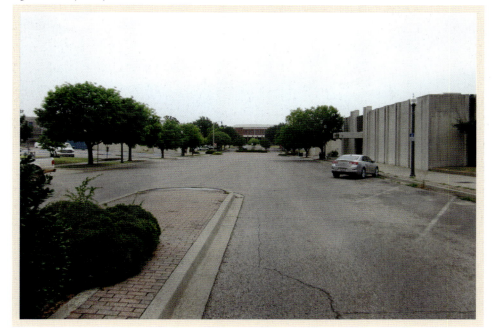

BELL STREET HISTORIC DISTRICT

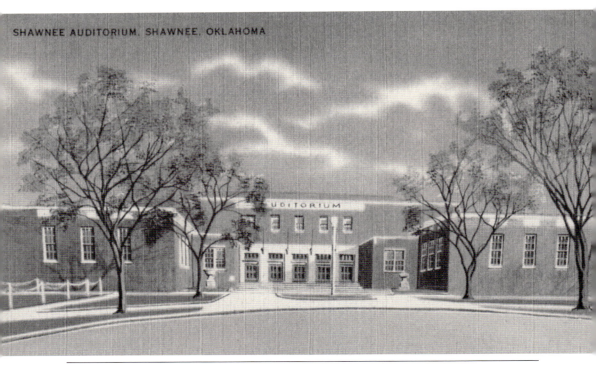

SHAWNEE AUDITORIUM, SHAWNEE, OKLAHOMA

The Shawnee Municipal Auditorium (shown in an early postcard) sits in Woodland Park and bookends the Bell Street Historic District to the north. It was constructed in 1936 as a Works Progress Administration (WPA) project. Approximately 20,000 people attended its inaugural celebration, which included a parade. The auditorium has been a meeting place for Shawnee citizens ever since, hosting high school graduations, sporting events, movies, conventions, and more. The auditorium was remodeled in 1991.

CHAPTER 3

Broadway Avenue

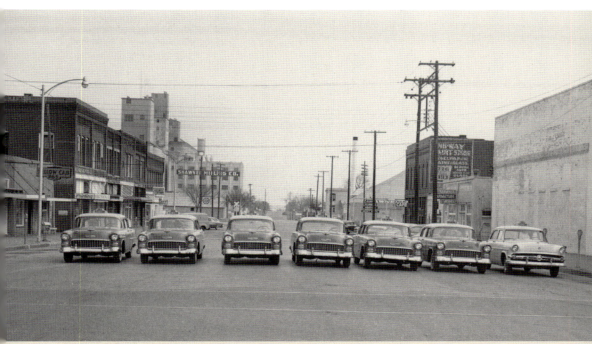

A fleet of seven cabs is lined up across Broadway Avenue in this 1950s promotional shot for Yellow Cab, which had its offices on Broadway Avenue just south of Main Street. The Shawnee Milling Company can be seen standing tall in the background. Like a lot of buildings on Broadway Avenue, many seen here have disappeared over the years.

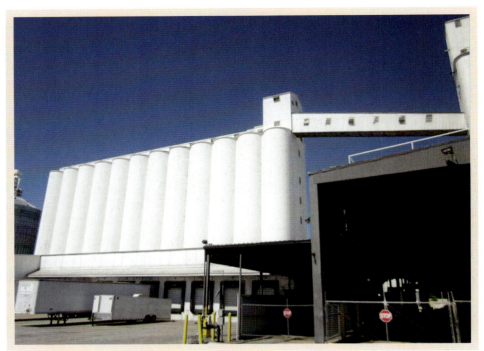

Shawnee Milling Company has been a mainstay of Shawnee for over 100 years. The original flour mill was built in 1891 south of Shawnee. The mill moved to the current site in 1895 and gradually grew. The mill burned in one of the worst fires in Shawnee's history in August 1934. A new facility, pictured at right in 1957, was built the following year and still produces flour, gravy, and other mixes loved in the state and beyond.

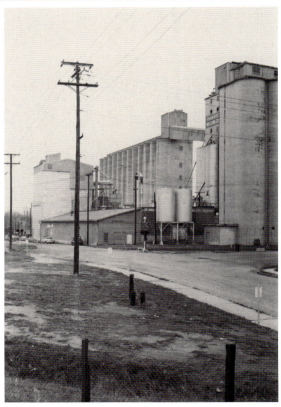

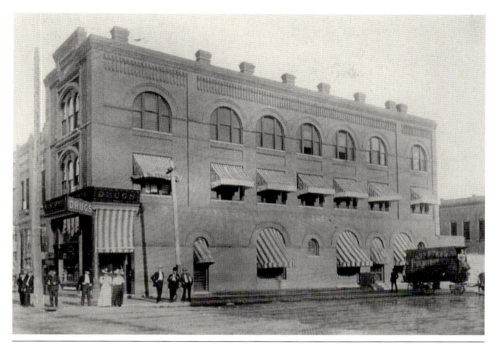

The Broadway Avenue side of 1 East Main Street can be seen in the early-1900s photograph above with a drugstore occupying the ground floor of the Main Street frontage. Prior to Prohibition, this building was home to the House of Lords, a self-proclaimed gentleman's resort. Central Drug would later move here. Although the Main Street side of this building has been covered, the wider Broadway Avenue face is mostly historically intact.

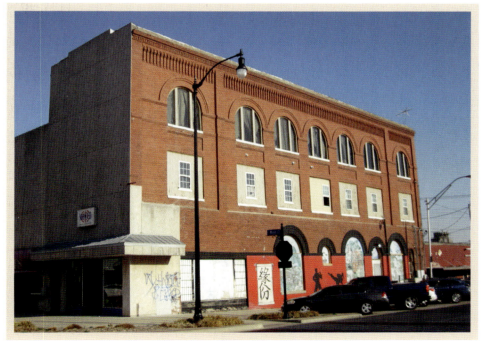

Broadway Avenue

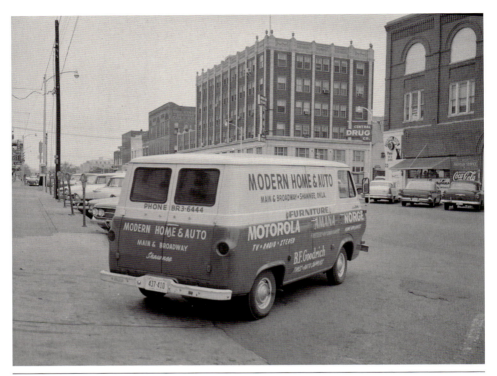

A delivery van for Modern Home & Auto sits on Broadway Avenue near Main Street in this c. 1960s photograph. In the background are Central Drug Co., American National Bank, the Business College Building, Baker Hotel, and the Hawk Building. The top of Modern Motors is just visible as well. The Broadway Avenue and Main Street anchors still exist, but the rest of these buildings have been lost to time.

The very early Shawnee postcard below captures Broadway Avenue looking north from Ninth Street. Two prominent buildings, roughly in the center of the photograph, are the city hall and Central Business College. Broadway Avenue today looks radically different, with many of its old buildings lost. Some, including city hall, were casualties of the 1970 tornado that tore through downtown. Others were removed to create surface parking.

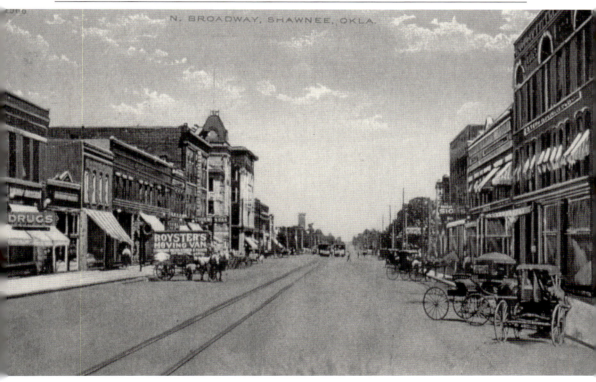

BROADWAY AVENUE

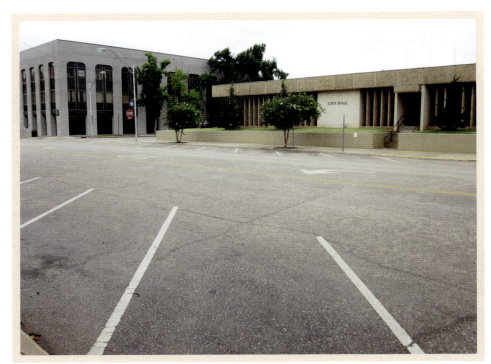

In the 1947 photograph below, a band marches north on Broadway Avenue during an American Legion parade. In the upper left corner are the Elks Building, Shawnee City Hall, and the City Hall Annex Building. Only the Elks Building survives today, although the facade is markedly different. City hall was torn down in 1971 after being devastated by a tornado the previous year. A replacement structure resides on the site today.

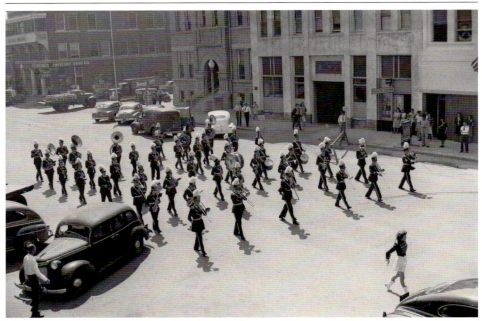

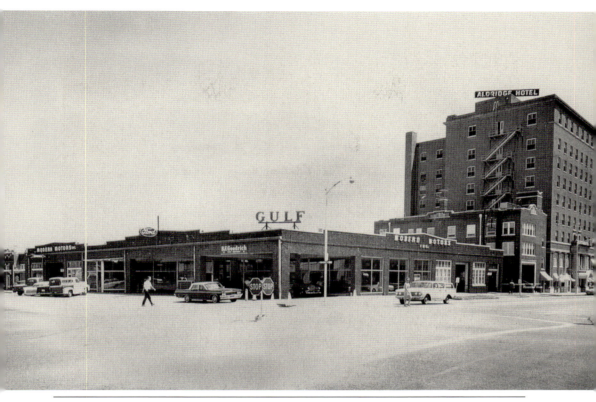

The northeast corner of Broadway Avenue and Ninth Street was once home to Modern Motors, which can be seen above as it looked in the 1950s. Also in the picture is the ACH Hospital and the west side of the Aldridge Hotel. While the latter two buildings survive today, American National Bank constructed a new building on the Modern Motors site in 1965, moving from its previous home at Main Street and Broadway Avenue. The bank is now known as Arvest Bank.

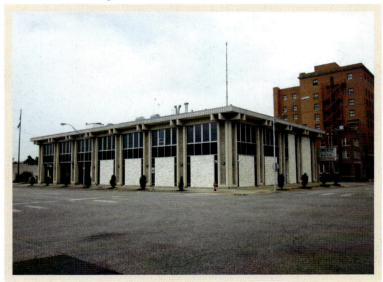

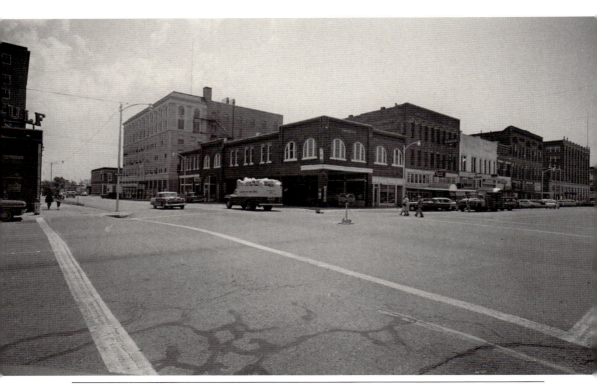

This photograph shows the southeast corner of Ninth Street and Broadway Avenue. Visible on Broadway Avenue are the Hawk Building (constructed 1902), Baker Hotel/VFW Building (erected 1904), Western Business College Building, and American National Bank. Unfortunately, almost this entire block of buildings is gone today, with many being razed in 1974. The bank building (on Main Street and not visible in the current photograph) still exists, as do the structures in the background at Bell Avenue and Ninth Street.

The Motor Parts Company was located at 316 North Broadway Avenue, just across from the Pottawatomie County Court House. Below is how the building appeared in 1965. It was previously home to the English Motor Company, which was a dealership for Packard and Studebaker automobiles. While the garage at left did not survive, the main building, clad with a new facade, lives on. It now serves as office space.

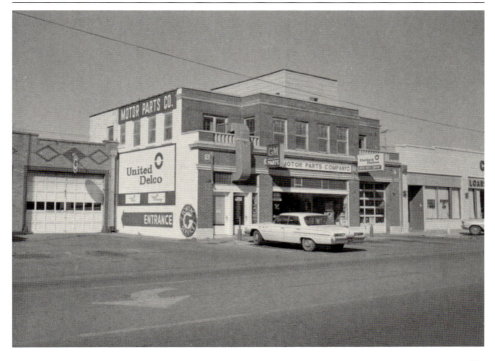

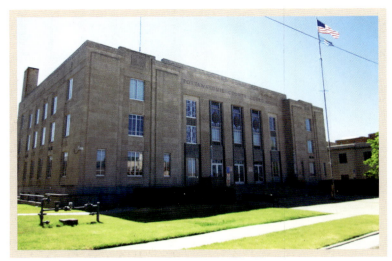

The Pottawatomie County Court House, located at 325 North Broadway Avenue, was built in 1934. The photograph below shows it shortly after completion. It features Art Deco styling, one of the few courthouses in the state to do so. The elaborately carved granite panels above each doorway and the metal decoration of the doors and windows further set it apart. The courthouse is listed in the National Register of Historic Places and continues to serve Pottawatomie County today.

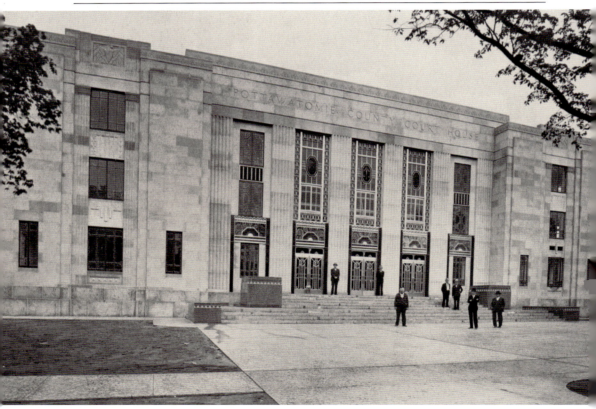

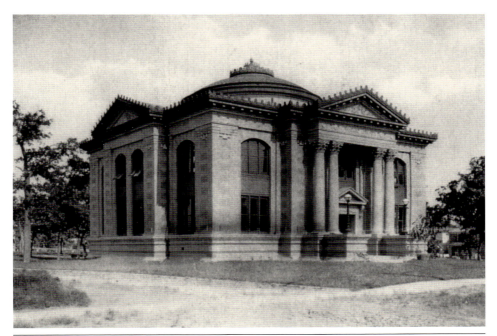

Shawnee's Carnegie Library was built in 1905 at 331 North Broadway Avenue, almost 30 years before its courthouse neighbor. The library was badly damaged in a fire in 1929 and lost its dome and ornate trim. The building continued to serve as a library until 1989, when the library moved and the structure was remodeled for the district attorney's office. The building still serves this function today. (The present photograph is taken from the opposite angle due to tree growth.)

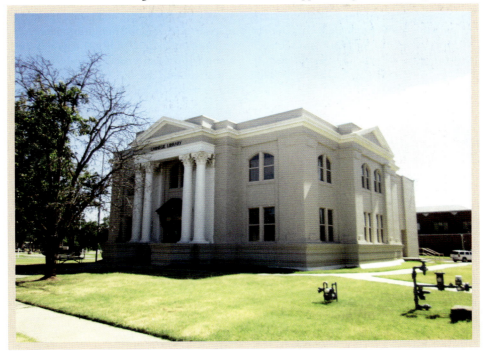

Broadway Avenue

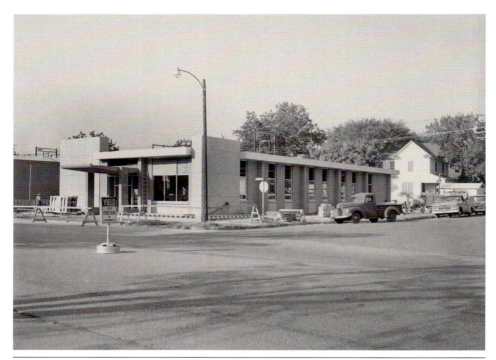

The First Christian Church called the corner of Broadway Avenue and Eleventh Street home for almost 40 years, but when the building was declared unsafe in 1948, it was torn down. First Federal Savings and Loan broke ground on a new office building in this spot in April 1963. This is how the building looked a few months later as it neared completion. The building now serves as home to the Pottawatomie County Election Board.

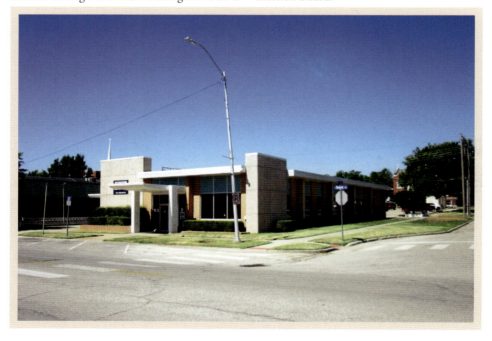

CHAPTER 4

ELSEWHERE DOWNTOWN AND BEYOND

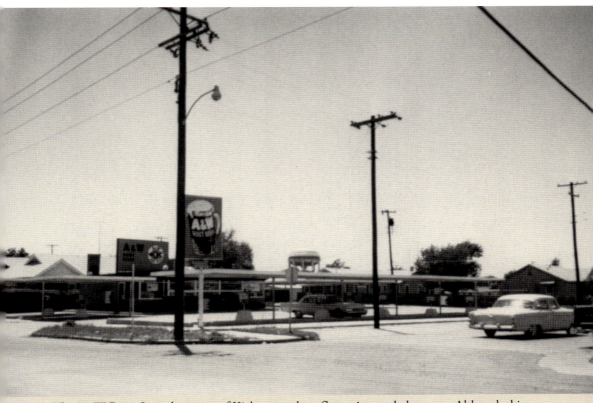

The A&W Drive-In at the corner of Kickapoo Avenue and Franklin Street is pictured in this 1962 image. Some Shawnee residents may recall driving in here for a burger and a root beer float—in a real glass mug. Although this building still exists, it has been modified over the years and the canopies removed. Shawnee's A&W Drive-In is only a memory today.

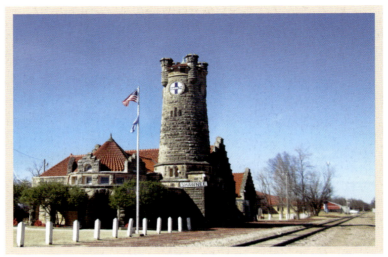

Several workers and a locomotive are pictured below outside the Santa Fe Depot (c. 1910s). The unique and visually striking depot, classified as Romanesque Revival, opened in 1904. The depot was active until 1956, after which it sat empty for over two decades. In 1982, the restored depot welcomed its first visitors as a museum. It was used as such until 2021, when a new museum was opened nearby. The depot still proudly stands but awaits restoration.

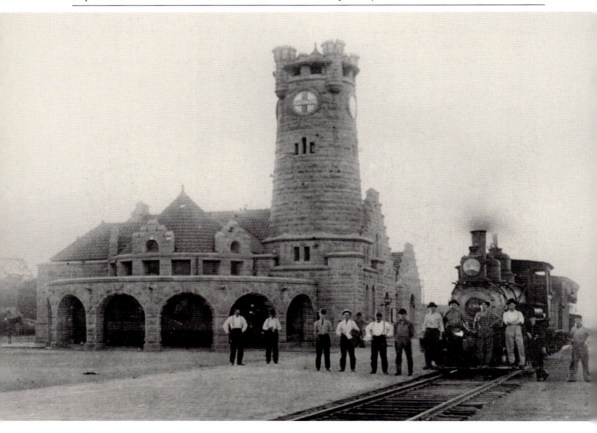

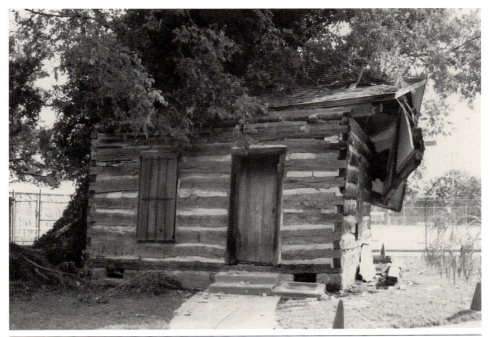

Beard Cabin is an approximately 15-by-20-foot log structure originally erected about 1892 at Kickapoo Avenue and Highland Street. Built by Henry Beard, it is considered the first home constructed in Shawnee. The cabin was moved to the historic Woodland Park area in 1928. In the 1950s, it was restored. The structure made one more move in 1990 to the Santa Fe Depot grounds, where it sits today. At the time of the present photograph, work was being performed on the roof.

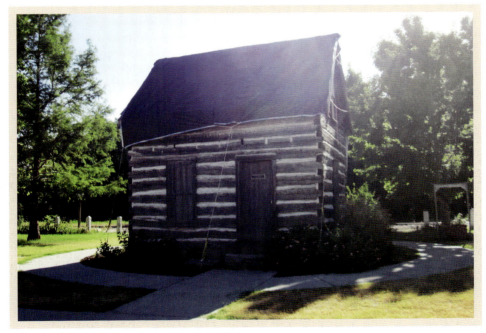

The 1957 photograph above shows the Aldridge Hotel and Federal Building Post Office on Bell Avenue from the vantage point of Ninth Street and Union Avenue. Both the Aldridge Hotel and the post office still exist today; however, the Chevrolet dealership has been replaced by an expansion of the post office. The large two-story home, along with all other homes on Union Avenue in this block, have been lost as well.

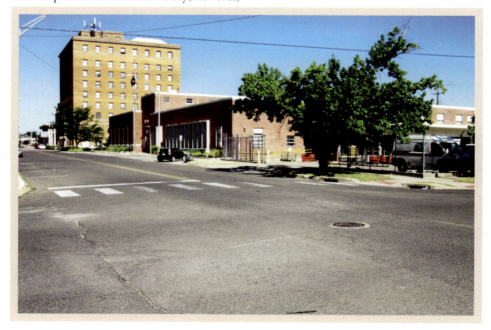

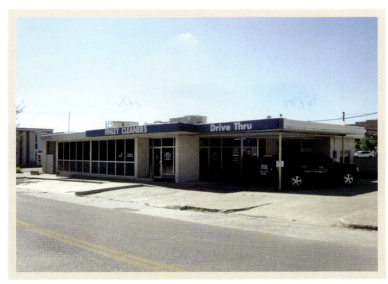

Shawnee residents have been taking their clothes to Finley's Cleaners at 15 East Tenth Street since the 1950s, when they could get five shirts washed for $1, suits and dresses pressed for $1.15, and pants cleaned for only 65¢. Although the prices may have changed today, Finley's is still serving customers at this location.

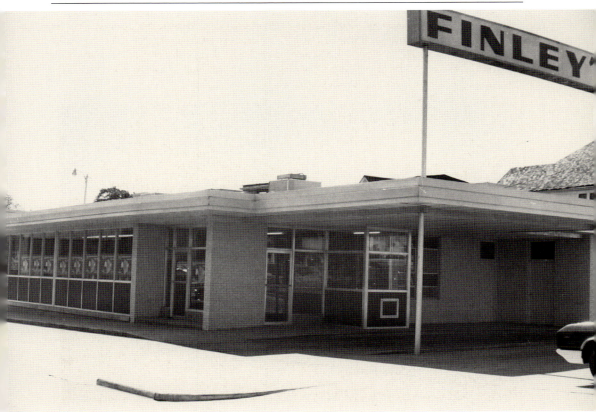

Below is a 1927 street view of Union Avenue looking south from Ninth Street. On the left are the convention hall, Gaskill Funeral Home, and at the end of the block, the Burt/Walcott Hotel. The convention hall was torn down a few years later to build the Union Bus Station (which is now also gone). The Walcott, at the corner of Main Street and Union Avenue, survived longer but burned in the 1970s. The Gaskill Building still stands. All the buildings on the west side of this block are gone.

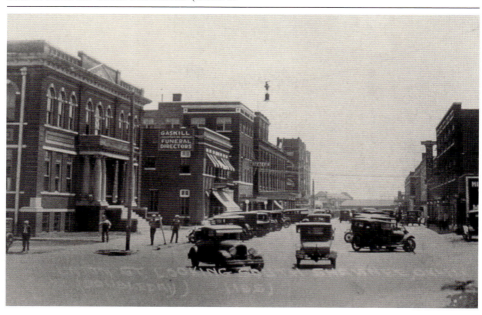

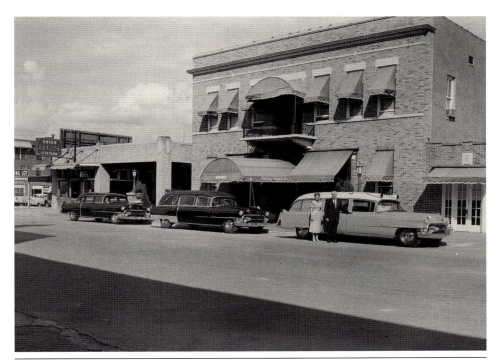

Gaskill Funeral Home was located on Union Avenue, sandwiched between the Union Bus Station (previously the convention hall) and the Burt/Walcott Hotel. Constructed in 1905 as Carey Bus and Boarding Stable, it is one of Shawnee's oldest standing buildings. It was sold and opened as Gaskill's in 1914 (shown above as it appeared in 1955). Although Gaskill's is gone, the almost unrecognizable building lives on, the victim of an unfortunate face-lift that has not aged well.

ELSEWHERE DOWNTOWN AND BEYOND

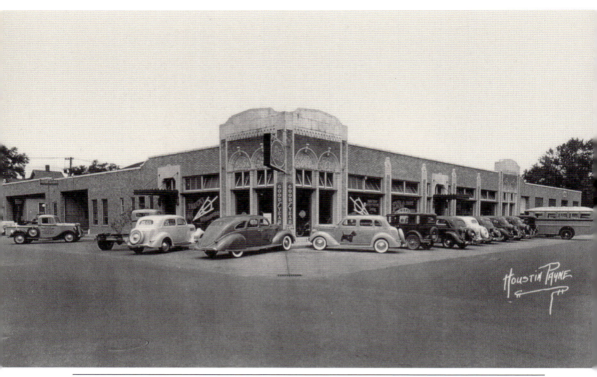

Hidden away at Ninth Street and Louisa Avenue is this gem of a building, once home to Modern Motors Lincoln Ford, which is shown above in 1936. The building later served as a trade and industrial education building for Shawnee High School. The building still stands today, the brick painted but holding mostly true to its former self. It is now home to the nonprofit South Central Industries.

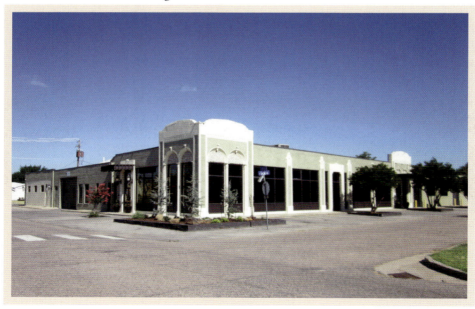

The photograph below shows Busseys Super Market at 712 East Highland Street as it looked in 1947. The market opened in 1945. By the 1950s, the store would tack on an addition, almost doubling in size. In the 1960s, the name changed to Bussey's Foodliner. The building still stands today but is covered in a stucco facade and serves as an auto dealership.

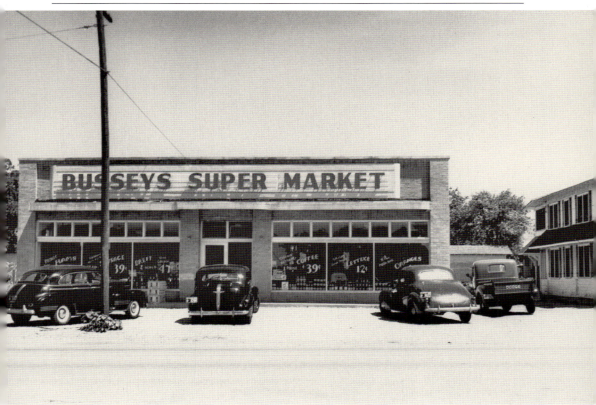

Mary Carter Paints occupied this building at 430 North Tucker Avenue. It is pictured below in 1961, the year it opened. The store was owned by Artice and Mildred McKinney and advertised a free second can of paint with every purchase. At the time, Mary Carter Paints was a popular name. This Shawnee branch was one of 700 in operation over a 36-state area. This building survives, and although the brick has been painted, it is still highly recognizable.

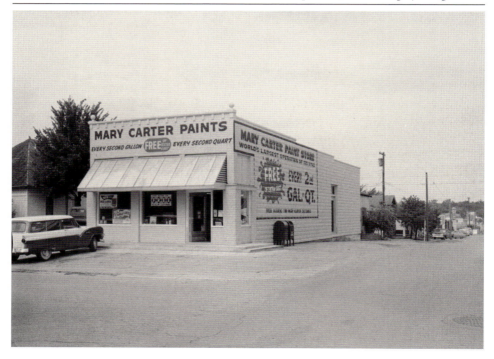

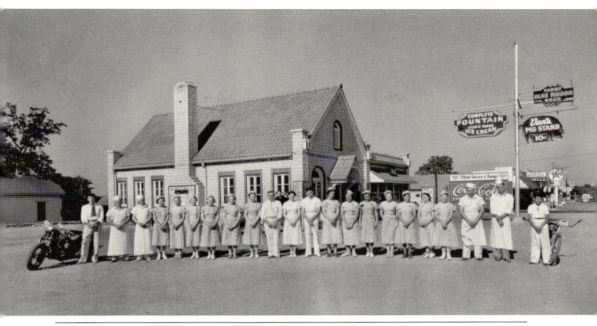

Van's Pig Stand already had restaurants in Wewoka and Seminole when it opened its Shawnee location in 1930. In 1935, Van's moved the restaurant across the street to its current spot at 717 East Highland Street (shown above with employees posing outside the restaurant in 1937). It is now one of four locations in the state and continues to welcome barbecue lovers today.

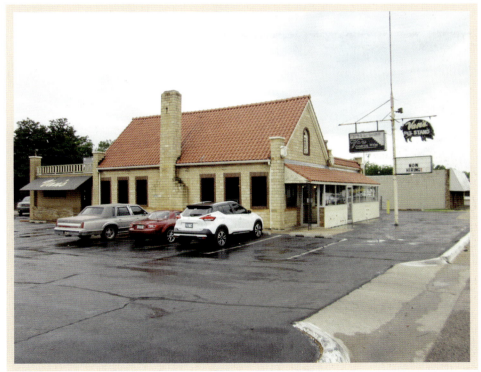

ELSEWHERE DOWNTOWN AND BEYOND

This three-story home at 618 North Park Street was built in 1903 in one of Shawnee's first neighborhoods. At the time, officials felt Shawnee was in the running to be the state capital and built this home with the intention of it serving as the governor's mansion. When Guthrie was chosen as the capital, the home was used as a private residence instead. As the neighborhood declined, so did the home, and it is now a sad shell of its former self.

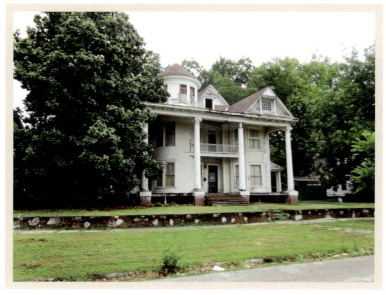

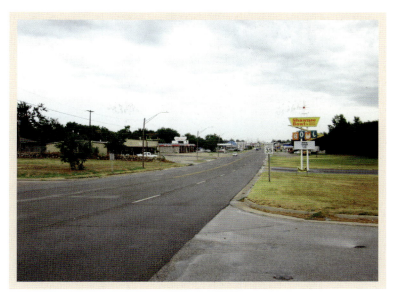

Pictured below is a view of Harrison Street (State Highway 18) in 1964 looking north. On the right is the Trico Bowl (now Shawnee Bowl), which opened in 1960. Both the sign and the bowling alley still exist today. Farther down the street on the right, the elevated car outside S&S Auto Salvage is visible. Noticeably, the street has increased from two lanes to four.

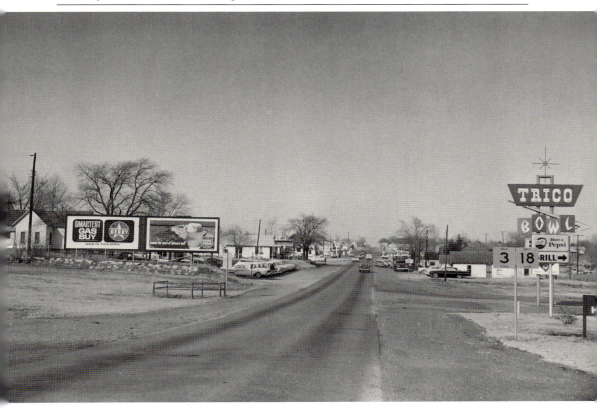

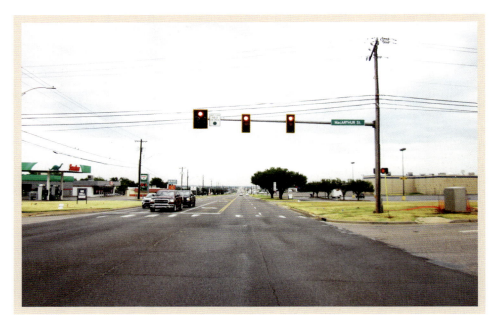

Below is how the intersection of Harrison Street (State Highway 18) and MacArthur Street appeared in 1972. The Starlite Drive-In opened in the late 1940s. In 1980, a twin indoor theater was built next to the drive-in, and the two shared a common lobby and concession area. In 1987, the drive-in was closed, and the twin theater was expanded to an eight-screen complex, now known as the Cinema Centre 8, which is still operating at this site today. The drive-in was later razed.

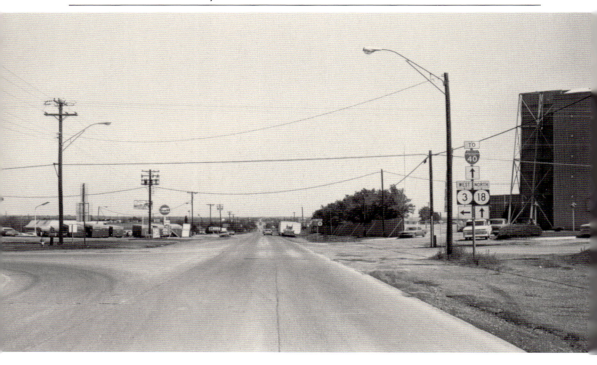

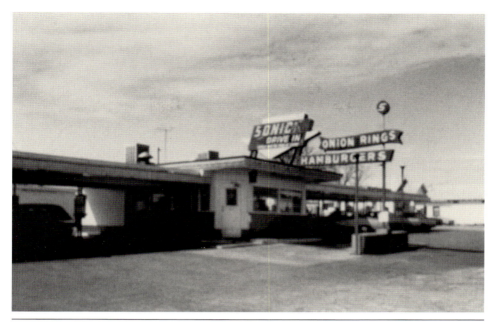

In 1953, a small stand selling root beer, hamburgers, and hot dogs named Top Hat opened in Shawnee. Six years later, after the construction of a handful of locations, the business changed its name to SONIC, America's Drive-In. Pictured around 1960 is the first SONIC in Shawnee, which was located at 1130 North Harrison Street. This SONIC eventually moved to a lot next door, and a strip mall was built in the old location. (Past image courtesy of America's Drive-in Brand Properties LLC.)

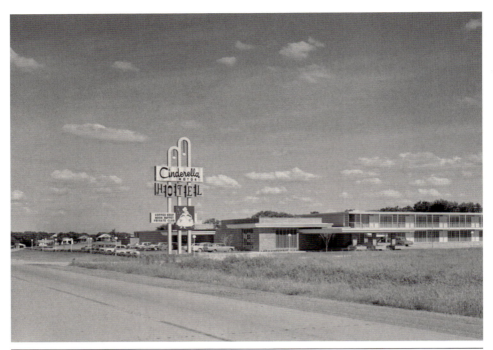

This photograph shows the Cinderella Motor Hotel (later the Cinderella Inn & Suites) at 623 West Kickapoo Spur in better days. Countless people will recall having their meetings, weddings, parties, and proms in the hotel, which opened in the 1960s. After many years of decline, the hotel was closed and abandoned. In December 2022, a fire damaged the property. It was later determined the hotel would be razed.

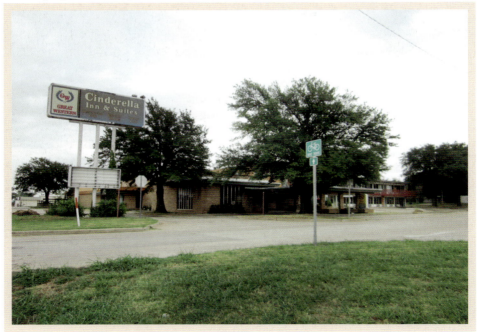

CHAPTER 5

Schools and Churches

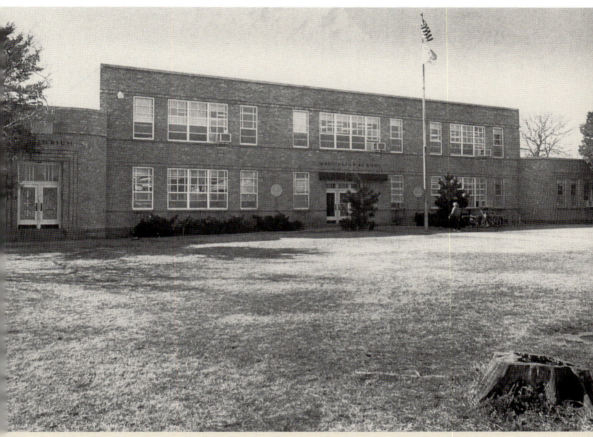

Many historic schools and churches can be found throughout Shawnee. One example is the Washington School, located in Farrall Park. Constructed in 1937, the school was once a handsome structure but has suffered from years of neglect—a plight shared by many old schoolhouses. Fortunately, alternative uses have been found for some of the other historic school buildings downtown.

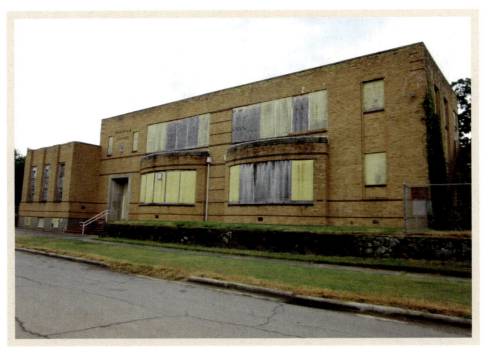

The two-story Ben Franklin School, located at 214 South Pennsylvania Avenue, was completed in 1939, a project of the Works Progress Administration (WPA). Franklin School is a classic example of urban schools constructed by the WPA. Washington School in Farrall Park shares a similar Art Deco design. While this building and Washington School still exist, both are boarded up and abandoned.

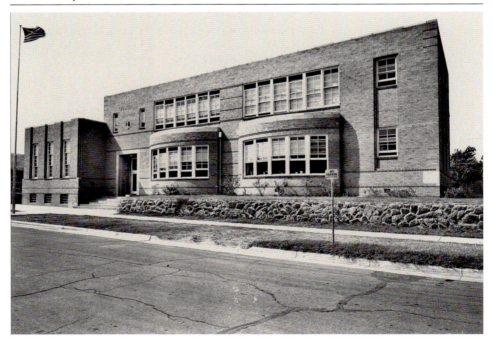

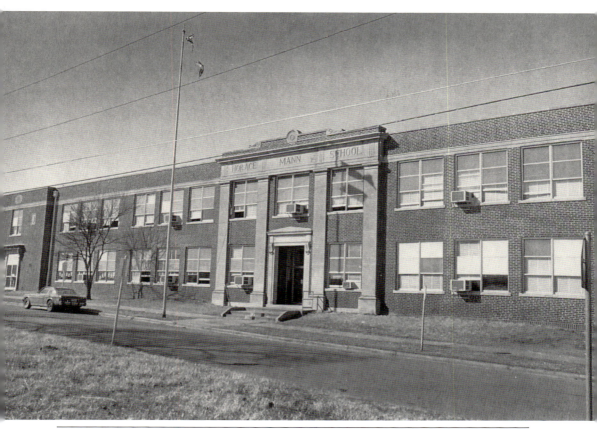

A Horace Mann School has existed at Eleventh Street and Draper Avenue since 1906, but the "modern" school building pictured here was constructed in 1928. The schoolhouse was quickly outgrown, so an auditorium and additional classrooms were neatly added to the west side of the structure in 1940, a project of the WPA. The building still serves as an elementary school today.

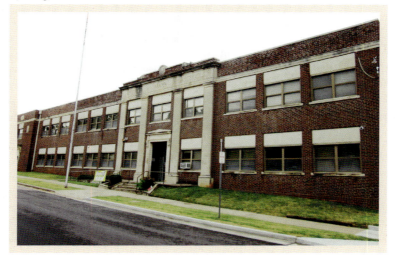

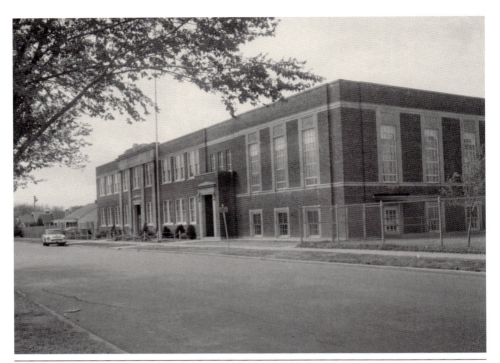

Woodrow Wilson School, constructed in 1928 at 1830 North Beard Avenue, shares a somewhat similar design to Horace Mann School. This site was previously home to the Rose Garden School, and that c. 1912 schoolhouse is still extant elsewhere on the property. A cafeteria and an auditorium were added to the end of Woodrow Wilson School in 1941, another WPA project. The building now serves as an adult learning center.

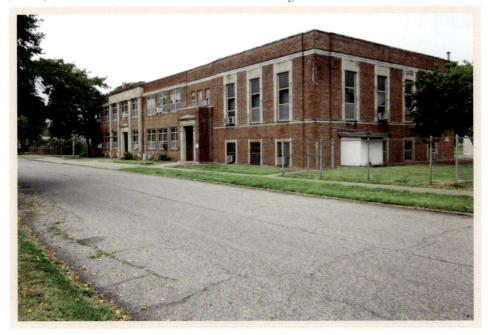

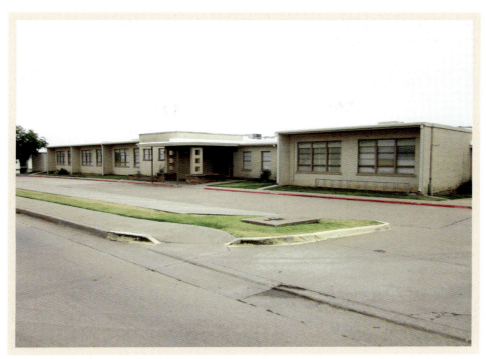

Named for the famous Oklahoma humorist, Will Rogers School was built in 1953 at Union Avenue and MacArthur Street. Additions were made to the building in 1968, and in 1990, a cafeteria and auditorium wing was added, along with more classrooms and offices. The building continues to serve as an elementary school today.

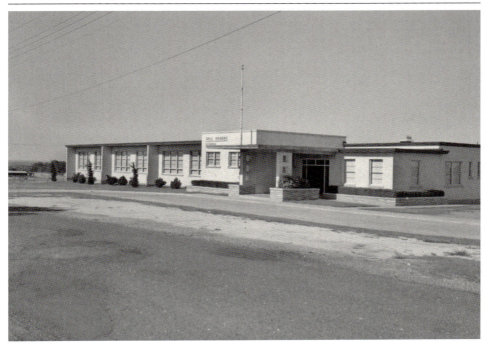

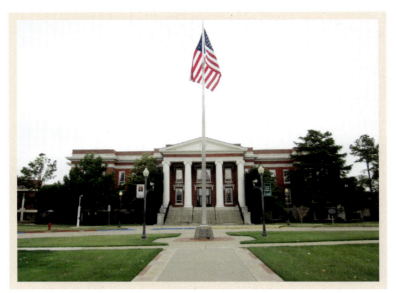

Oklahoma Baptist University (OBU) first opened in Shawnee in September 1911. The first classes were held in the basement of the First Baptist Church and in the convention hall. Due to financial exigency, OBU operations were suspended for three years after graduating its first class. Shawnee Hall, pictured, was the first building on the new campus and opened in September 1915. In January 1964, a plane crashed into the south side of the building, causing extensive damage but no injuries.

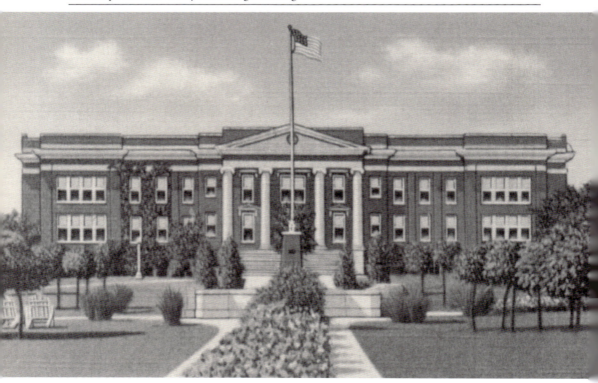

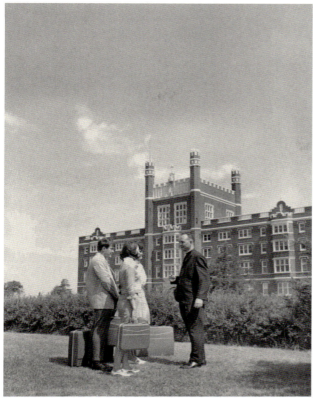

St. Gregory's University traces its roots to the Sacred Heart Mission near Asher, Oklahoma. After that mission suffered a disastrous fire, the monks began planning for its replacement in Shawnee. St. Gregory's opened its doors in 1915 with Benedict Hall (shown here in 1966) being the original building. Sadly, St. Gregory's ceased operations in 2017. The campus was sold in 2018 and donated to Oklahoma Baptist University the following year. It is now known as OBU Green Campus.

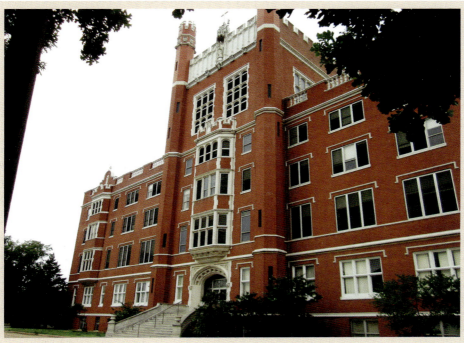

SCHOOLS AND CHURCHES

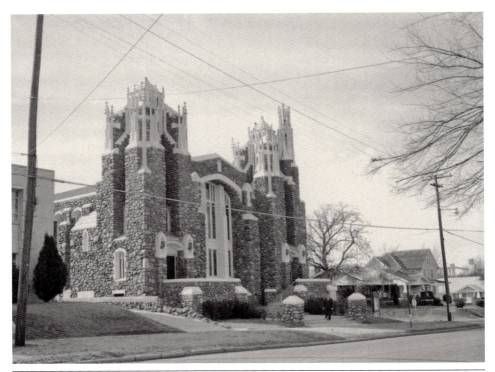

Draper Street Baptist Church (organized in 1917) moved to this building at 1101 East Main Street in 1929 and renamed itself Immanuel Baptist Church. The structure features Arkansas native stone and is known for its beautiful stained-glass arched windows, a few of which can be seen in the 1966 photograph above. The church body later moved to a new facility on Forty-Fifth Street, where services are still held. The 1929 building is now home to an outreach center.

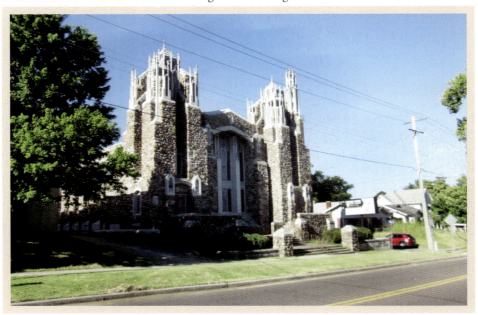

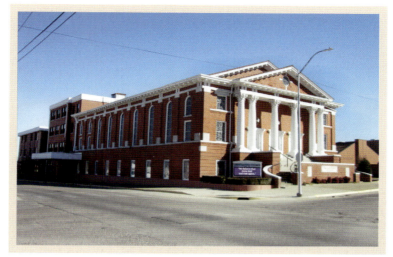

Shawnee's First Baptist Church was organized in 1892. Its current home at 227 North Union Avenue was dedicated on Sunday, June 27, 1909. The structure was originally built with a dome and two bell towers; however, these were later removed during a remodel of the church. Although the church building has seen a lot of changes over the years, it still stands prominently at Tenth Street and Union Avenue.

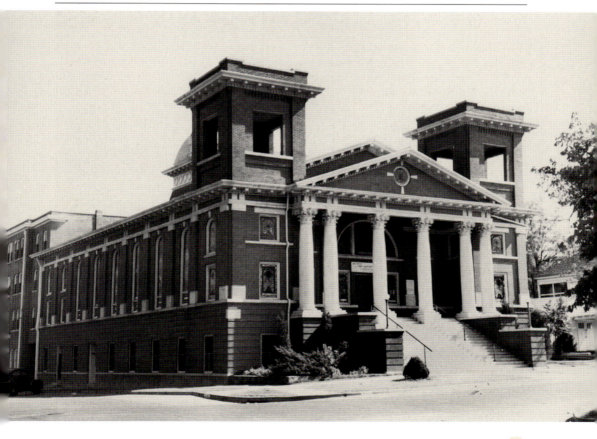

Schools and Churches

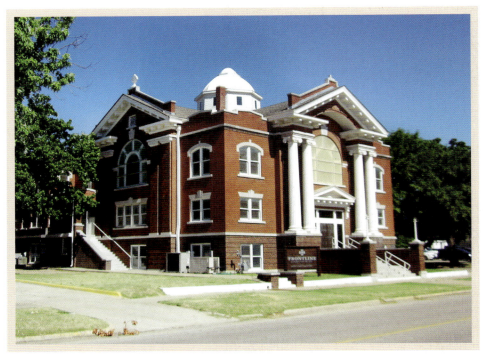

First Presbyterian Church (shown below in 1967) held services for decades at 330 North Beard Avenue. In the 1990s, First Presbyterian merged with Central Presbyterian Church and continued at this location as United Presbyterian Church. In 2015, facing structural issues and declining membership, the decision was made to leave the historic structure and move to a remodeled storefront on Broadway Avenue. The building is now home to Frontline Church.

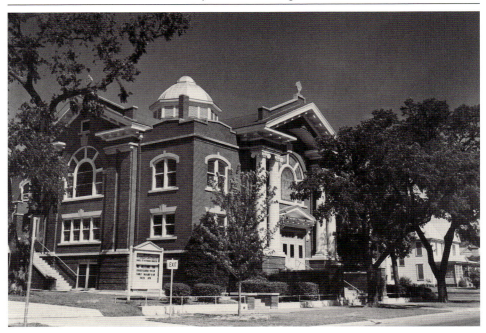

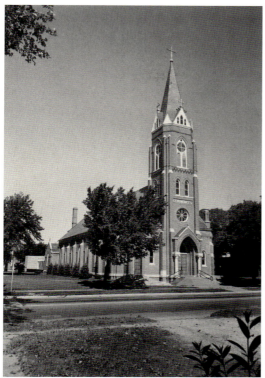

St. Benedict Catholic Church dates to 1895, when the church was located at Ninth and Park Streets. Outgrowing that facility, this church made the decision to construct a new building, and this structure at Kickapoo Avenue and Benedict Street was dedicated in 1907 (shown at left in 1967). In 1962, the inside of the church underwent extensive remodeling. In 2006, the stained-glass windows were refurbished. The church continues to operate from this location today.

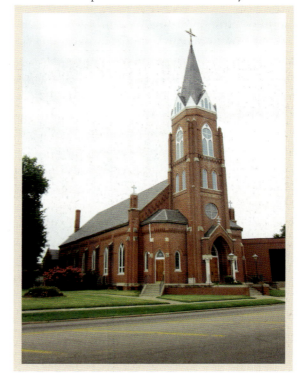

Schools and Churches

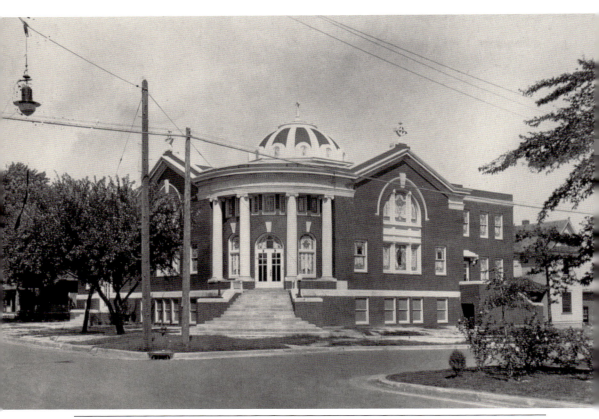

The First Methodist Church dates to 1894; however, the assembly has met at Tenth Street and Beard Avenue since 1901. The church pictured here was constructed in 1952, the third on the site. In 1964, the First Methodist Church and the Evangelical United Brethren merged. It has since been known as St. Paul's United Methodist Church. In 1970, a tornado damaged the sanctuary, and it had to be razed. A new structure was completed in 1973. St. Paul's still calls this home today.

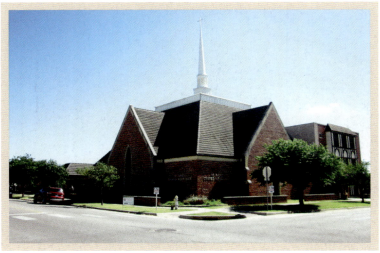

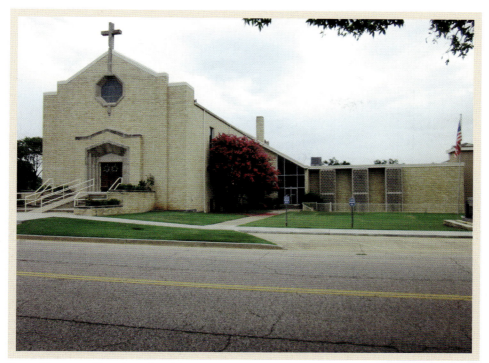

First Christian Church is the oldest church body in Shawnee, established in 1891. The church previously had a home at Broadway Avenue and Eleventh Street that dated back to 1907. That building was determined to be unsafe in 1948 and was later torn down. The church constructed a new building in 1950 (pictured below in 1965) at Broadway Avenue and Elizabeth Street. The church still has a home there, celebrating over 125 years in Shawnee.

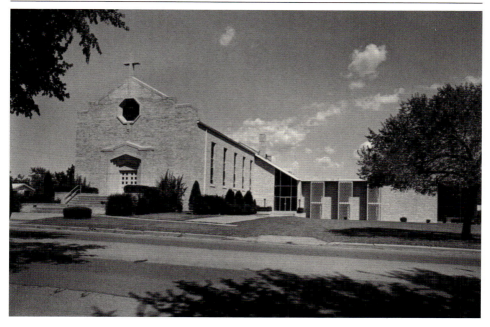

Discover Thousands of Local History Books
Featuring Millions of Vintage Images

Arcadia Publishing, the leading local history publisher in the United States, is committed to making history accessible and meaningful through publishing books that celebrate and preserve the heritage of America's people and places.

Find more books like this at
www.arcadiapublishing.com

Search for your hometown history, your old stomping grounds, and even your favorite sports team.

Consistent with our mission to preserve history on a local level, this book was printed in South Carolina on American-made paper and manufactured entirely in the United States. Products carrying the accredited Forest Stewardship Council (FSC) label are printed on 100 percent FSC-certified paper.